a comprehensive guide to digital portrait photography

ava

AVA Publishing SA
Switzerland

Published by AVA Publishing SA
rue du Bugnon 7
CH-1299 Crans-près-Céligny
Switzerland
Tel: +41 786 005 109
Email: enquiries@avabooks.ch

Distributed by Thames and Hudson (ex-North America)
181a High Holborn
London WC1V 7QX
United Kingdom
Tel: +44 20 7845 5000
Fax: +44 20 7845 5055
Email: sales@thameshudson.co.uk
www.thamesandhudson.com

Distributed by Sterling Publishing Co., Inc.
in the USA
387 Park Avenue South
New York, NY 10016-8810
Tel: +1 212 532 7160
Fax: +1 212 213 2495
www.sterlingpub.com

in Canada
Sterling Publishing
c/o Canadian Manda Group
One Atlantic Avenue, Suite 105
Toronto, Ontario M6K 3E7

English Language Support Office
AVA Publishing (UK) Ltd.
Tel: +44 1903 204 455
Email: enquiries@avabooks.co.uk

Copyright © AVA Publishing SA 2003

ISBN 2-88479-030-6

10 9 8 7 6 5 4 3 2 1

Design: Bruce Aiken
Project management: Nicola Hodgson
Picture research: Sarah Jameson

Production and separations by
AVA Book Production Pte. Ltd., Singapore
Tel: +65 6334 8173
Fax: +65 6334 0752
Email: production@avabooks.com.sg

a comprehensive guide to digital portrait photography

duncan evans

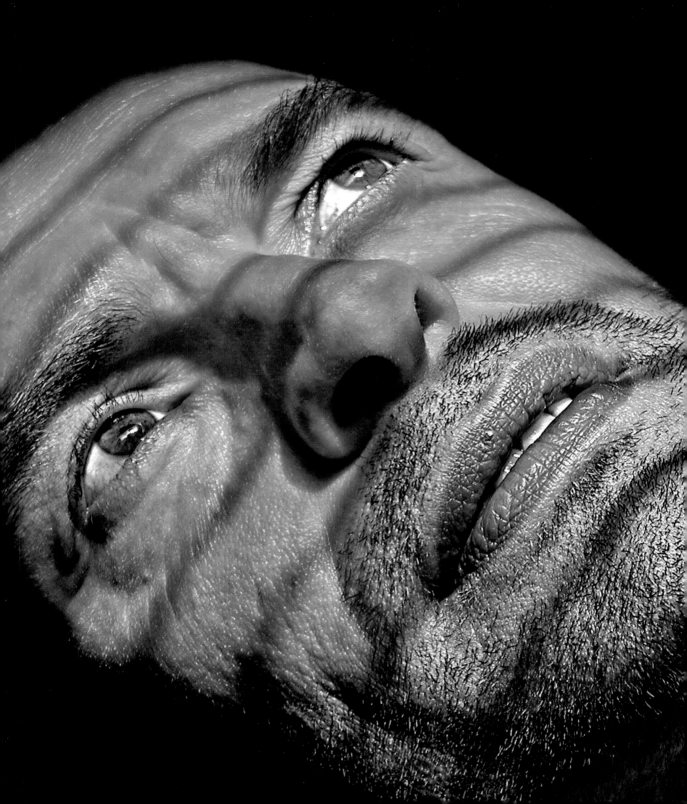

Captured by Trine Sirnes

contents

introduction

Digital technology is changing the face of photography, allowing more people to take pictures, be creative and learn skills that they might otherwise have found daunting. Traditional film photography has had a mystique about it; it has been a somewhat arcane skill in which only a few have been able to progress beyond the enthusiastic amateur stage. Digital has changed all that, largely because it allows instant feedback. The photographer can see straight away whether the composition worked or not; if the exposure was correct; if the creative effect was properly executed; if the spirit and emotion of the subject was captured. Because of that immediate feedback, it is possible to learn the technical aspects of photography much more quickly, getting over that initial hurdle where, in film photography, many would give up in frustration. With burgeoning confidence, digital photographers can soon progress to understanding what really makes one photograph stand out from another – they can acquire the 'eye' that all good photographers have, visualising the end result before they even pick up the camera.

In addition, digital allows you to correct mistakes that would otherwise condemn film to the bin. This isn't cheating; it helps to teach you what the mistake was and allows you to retrieve an image that would otherwise have been discarded. There are further advantages with digital. You become your own developer, darkroom and printer. There are no film or developing costs so you can shoot as many pictures as you like. The level of control on the PC in the digital darkroom is astounding, allowing you to take a photo where the conditions or the subject are far from ideal, knowing that, on the computer, you will be able to turn that picture into something spectacular. You can even take photos with the aim of combining them together later, thus creating a scene that a film camera could never do. When it comes to printing, you control what gets printed, when you want it, what size, what border, and with whatever effects you want. And you can change these parameters for every single picture without ever affecting the original.

Portraiture is perhaps the most creative branch of photography. Unlike landscape photography, where you are reliant on weather conditions to give you a glorious scene, portrait photography depends on you to set the scene, style the subject, create the lighting, set the mood and energy and decide how you want the emotion of the scene to be presented. There are many styles of photography that can be classified as portraits: unposed shots of children playing; formal family portraits; candid shots; fashion; nudes; costume sets; black-and-white pictures; grainy or moody shots; images in subtle or vivid colour. This book aims to show you how to shoot this carnival of humanity; how to enhance, improve and manipulate the image to your liking; and how to share your results by print, email, web page or however else you want to communicate your skills. So dive in; the adventure starts here.

Duncan Evans

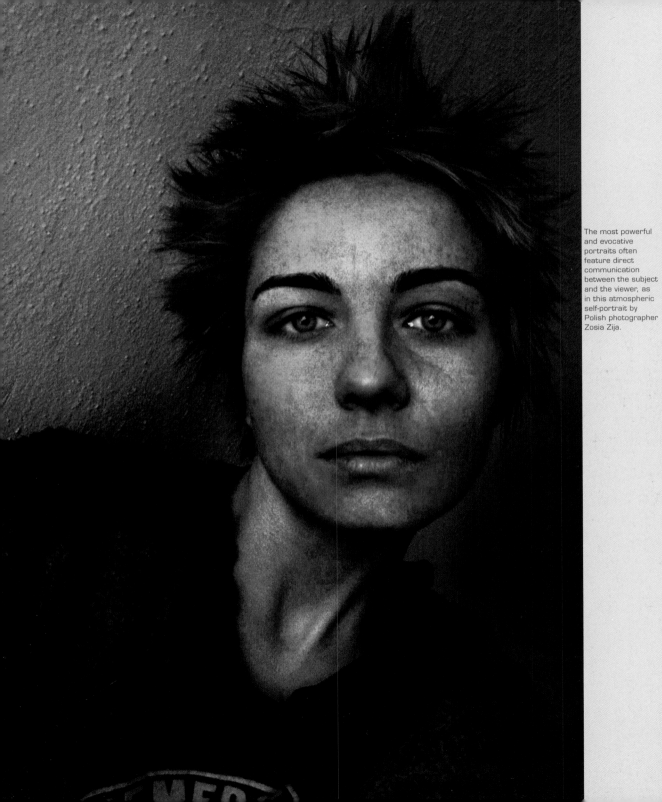

The most powerful and evocative portraits often feature direct communication between the subject and the viewer, as in this atmospheric self-portrait by Polish photographer Zosia Zija.

quotations

The photographer adds his or her own thoughts in their own words.

how to get the most from this book

This book is divided into nine chapters. The first chapter covers choosing the right kind of camera and finding subjects for your portraiture. The subsequent chapters each focus on a particular branch of portraiture, including shooting in studios, working on location, taking wedding portraits and photographing nudes. We also discuss correcting basic mistakes and making radical, creative changes to your images. The appendix includes a useful glossary of technical terms.

In each section, the photographer explains their progress from the original shot to the finished image, discussing what steps they took on the computer to achieve the final look. Each spread is backed up with practical tips to help you to improve your photography. Whatever your level of expertise and equipment, here are images to inspire you and insights into the photo-editing techniques that you can apply to create the portraits you aspire to.

introduction

An overview of the theme and techniques set out in the spread.

shoot – enhance – enjoy

Each spread is divided into the sections 'shoot', 'enhance' and 'enjoy'. 'Shoot' explains the background details up until the moment of capture. The choice of equipment and the context of the shoot are revealed. The 'enhance' section explains the process that the image has been through once in computer, outlining the stunning results that the digital photographer can create post-capture. The 'enjoy' section reveals how the image has been used for personal enjoyment or professional use.

flow chart

A step-by-step outline of the main stages that the image has gone through is given in a flow chart. This allows a quick reference to the same or similar points of interest on different spreads. The flow chart also enables the reader to determine at a glance how simple or involved an image was to create.

'Digital photography is great. It's fast and easy. You don't have to worry about running out of film in the middle of your session. You don't have to worry about overexposing your negatives.'

subdued colour

By removing most of the colours from a photo and leaving just one main hue, you can create very atmospheric portraits. The model should assume an understated, subtle pose to complement the colour treatment. The use of wide apertures to limit depth of field is also a good idea, and lighting should be sparse so that only the subject, perhaps with certain vague elements of the background, is illuminated.

shoot

This shot, by Zosia Zija of Warsaw, Poland, features the use of tightly reined-in colour to great effect. It was taken on a Canon PowerShot digital camera, fitted with an adapter in order to use a studio flash head with a softbox attachment to create even, flattering light. The model, Sylwia, was fairly inexperienced, so this subdued pose was easy for her to assume.

enhance

A duplicate layer was cre[ated] and the blending mode se[t to] Multiply. This has the effe[ct of] making a photograph dark[er] in a way whereby the dark[er] areas tend to become bla[ck]. The Burn tool was used to [...] overexposed highlights. Th[e] colour balance of the phot[o was] then adjusted by increasin[g the] amount of black in it, and [...] contrast was adjusted.

Finally, the Hue/Saturatio[n] control [3] was used. The c[olour] picker selected the red of [the] dress and this was then r[...] in saturation. The effect w[ould] darken the entire image, l[...] only the subtle reds of the[...] to match the subdued pos[e and] atmosphere.

enjoy

Zosia had been working on a digital portrait project to convince traditional film users that digital can achieve the same kind of subtle tones that film can. This image was created for her[...] exhibition showing just tha[t...]. It was also edited for use o[n...] websites by resizing the pr[int] density to 72dpi and resar[...]

> duplicate layer
> burn
> increase black content
> hue/saturation
> print
> resize for web

44 studio portraits

Often detailing the exact settings used for key stages of the photo-editing process, screengrabs make a quick and instructive visual check with which to follow the proceedings.

images

Portraiture is perhaps the broadest field of photography because it deals with people in all their variety. Digital portraiture expands this variety even more because it gives the photographer the opportunity to create new images from originals that were either fairly ordinary or simply not shot with the end result in mind. Flexibility, creativity and vision are the three common aspects of great digital portraiture, and you will find plenty of evidence of these in the images showcased in this book.

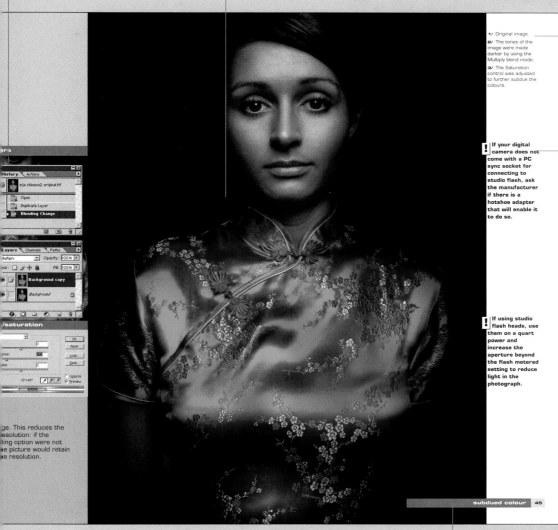

1/ Original image.

2/ The tones of the image were made darker by using the Multiply blend mode.

3/ The Saturation control was adjusted to further subdue the colours.

captions

The image captions clarify and recap the processes shown in each image.

! If your digital camera does not come with a PC sync socket for connecting to studio flash, ask the manufacturer if there is a hotshoe adapter that will enable it to do so.

tips

Practical tips from the author and photographer allow the reader to apply issues raised in the images discussed to their own creative work.

! If using studio flash heads, use them on a quart power and increase the aperture beyond the flash metered setting to reduce light in the photograph.

ge. This reduces the esolution: if the ling option were not e picture would retain e resolution.

subdued colour 45

spread title

1 getting started

Discover what sort of camera, studio space and lighting you need to take great portraits, and where to go to find people to pose for you.

This shot is in fact two separate photos of Trine's stepsons, who were aged 10 and 11 when the photo was taken in 2001. Both pictures, taken a few weeks apart, were shot in front of a window using only natural daylight.

Trine's first step was to work on the contrast on the eyes, to make them stand out from the greyness of the rest of the shot. After combining the two photos together, she created the high-key effect using Image > Adjustments > Selective Colours in Photoshop. She chose grey in the drop-down menu and turned the black on that far left. She did the same with the white, while the black she turned to the far right. After a few more minor adjustments with the contrast, the final touch was to add a little Unsharp Mask.

Siblings by Trine Sirnes

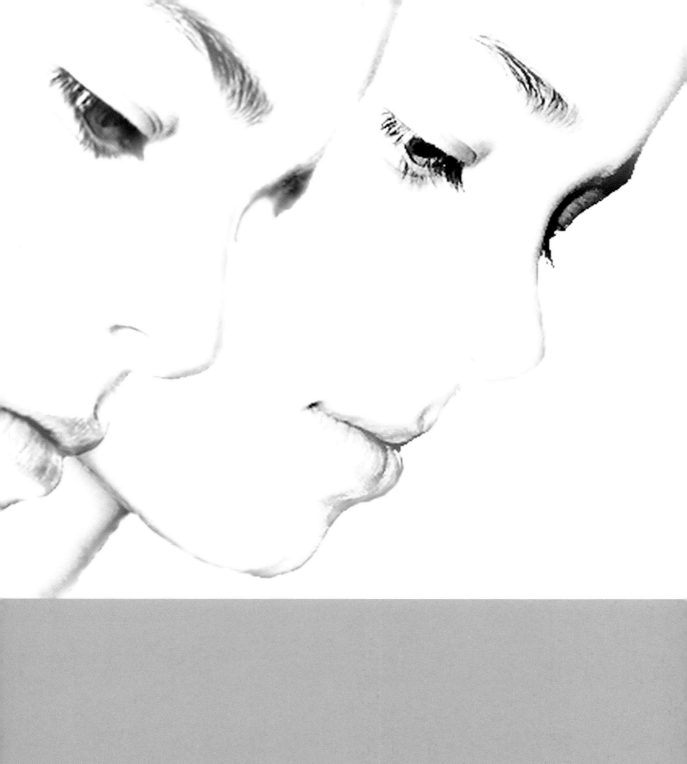

> **!** Fluctuations in light levels are recorded as coloured speckles, or 'noise', by the CCD or CMOS chip inside a digital camera. When there is plenty of light, this is rarely a problem. It is most prevalent on small package chips, packed with the highest resolution.

> **!** Scanned 35mm film produces around 7Mp of detail. Digital cameras producing 5Mp have less resolution, but the picture tends to be cleaner.

> **!** Digital cameras are rated by the megapixel. This is the horizontal and vertical resolution multiplied, and rounded off by the million. Thus, a camera that produces a 2400 x 1800 resolution image, containing 4.32 million pixels, is known as a 4.3Mp camera.

choosing a camera

There is a myth in photography that your camera equipment doesn't matter – it's what you do with it that counts. Of course, there is no such thing as the magic camera, with preset dials for glorious sunsets, fantastic wildlife shots, or heart-stopping action. And someone with no intrinsic talent will never take a great shot, even if they have the most expensive equipment in the world. However, your choice of camera will affect what kind of pictures you can take, and the control that you have over the picture-taking process.

the basics

At the bottom end of the digital camera market there is the automatic point and shoot. While it is perfectly possible to take a well-composed portrait, with dramatic natural lighting, and then significantly enhance the shot on computer, you need all conditions going in your favour initially because you cannot control the exposure. You also have to live with a low resolution that costs you detail; indifferent colour reproduction; barrel distortion from the lens; and a lack of sharpness.

There are basically three types of digital camera worth considering: the controllable compact; the SLR-style compact; and the digital SLR itself. Currently, the resolution available to the first two categories is around 5Mp; the 6Mp Fuji cameras use interpolation. This figure will only go up in the future, and if you are at all serious about taking pictures, you shouldn't consider a camera with anything less. Resolution means detail, and no matter how sophisticated your computer software, if the detail isn't there in the original shot, it is very difficult to create it later.

camera types

A 5Mp, controllable compact will give you a lightweight and conveniently sized camera, where the aperture and shutter speed can be controlled. The lens quality won't be great, but it will give you the basics for getting started.

The SLR-style compact looks like a miniature SLR, with an all-in-one lens and body. Unlike the compact, it is festooned with controls for altering the exposure through program modes, exposure compensation, variable ISO and a variety of metering options. In short, it will give you more control over the picture-taking process, allowing you to get the best picture possible in the first place. Some makes have a PC-sync socket that allows studio flash systems to be connected and controlled. These cameras are a good choice for those with the desire to be creative and take lots of photos, without spending a huge amount of money. However, compared to the digital SLR cameras (see below), the lens quality isn't as good; the speed of shooting is slower; the resolution is usually lower; and the images have more 'noise'.

Perhaps the key factor in portraiture is this: compact digitals produce as much as six times more depth of field at wide angles. Depth of field is

the amount of the photo in sharp focus from front to back. With a wide aperture, focusing on a person in a room, an SLR will throw the back of the room completely out of focus. A compact will show all the detail in the room, and, while the back won't be sharp, everything in it will be visible, and potentially distracting.

The digital SLR, with interchangeable lenses, is the most expensive option – double or more of the cost of the previous category – but offering far superior handling, shooting and focusing speed, and better quality photos. If you are serious about photography, and have the money to spare, a digital SLR is your best choice.

! **Digital ISO changes the strength of signal required to generate a pixel in the final image. By halving the signal strength required, the camera becomes twice as sensitive. However, the lower the light level, the more variable the signal strength becomes, causing noise to be generated. High digital ISOs are very sensitive to low light, but can produce a noticeable amount of noise. In some cases this renders the image fit for use only in black and white: the noise takes on the appearance of digital 'grain', as found in sensitive film stock.**

! Light is given a colour temperature scale in degrees Kelvin that runs from around 2000K for candlelight, up to 8000K for bright but cloud-covered days. Average daylight temperature is set at 5500K. Tungsten and fluorescent lighting both have lower temperatures, so that any camera (or film) set to use daylight temperature will record a yellow or green colour cast.

the studio and lighting

Having your own studio gives you much more creative freedom for your portrait photography. If you cannot afford the expense of a studio by yourself, there are two alternatives. The first is to rent studio space as and when you need it. This option is probably only for those with plenty of money or a commercial requirement. The other option is to have a studio room in your own home. That doesn't mean that you need a converted warehouse, complete with a mountain of lighting and background sets and an army of assistants on hand.

studio

Any spare room can easily be dedicated to photography by removing all the furniture, painting the walls white (this removes any colour casts that could otherwise be thrown into the picture) and either using a background cloth and pole system, or simply fixing a curtain rail across a wall and hanging black curtains on it. Another option is to employ a room that is usually occupied, but that can be temporarily converted for studio use by moving the furniture into one corner. Obviously you need a fairly large room to be able to do this.

lighting

Photography is all about using light. Light from a window can be very useful, especially if the afternoon sun, with a golden yellow-orange colour, is diffused through net curtains. Natural light should not be your only source though, because you will be scuppered if it happens to be raining when you want to do a shoot. Artificial light needs to be employed instead. There are five basic types:

Built-in flash

Most digital cameras, even the digital SLRs, have built-in flash. This should only be used in slow-sync or fill-in flash mode. On full power it flattens features and ruins photos. It is almost guaranteed to produce the red-eye effect that occurs when light hits the blood vessels at the back of the retina and bounces out to the camera.

Hotshoe flashgun

The hotshoe flashgun has the advantages that the flash head can usually be tilted so that it isn't facing the subject directly, and also that diffusers can be fitted to the face of the flash unit itself.

1/ One of the most basic and affordable lighting set-ups that creates a professional look is the flash head and reflecting umbrella.

2/ A tungsten lamp on a tripod. The colour temperature of tungsten lamps is set at 5500K, and a digital camera can match this for perfectly white exposures.

3/ Photography is all about exploiting light. It takes as much skill to use natural lighting to effect as it does to work with professional studio lights, as evidenced by this evocative windowlit nude.

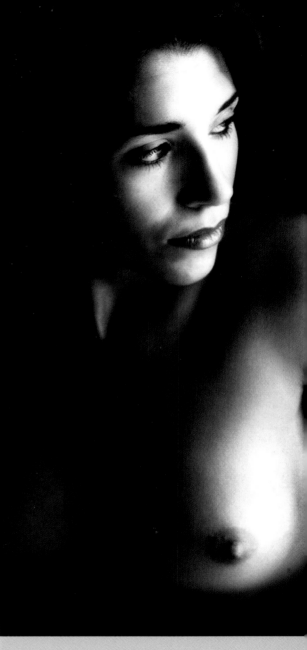

3

System flash

These units are more specialised and usually fit onto a bracket that connects to the camera. A lead connects to the camera itself. These units are powerful and you can use diffusers with them. Another advantage is that, as the unit sits on top of the camera, the problem of red-eye is removed.

Tungsten lamps

These were not that popular with film cameras because they caused problems with colour casts, but, as many digital cameras can set their white balance temperature manually to match the temperature of the lights, tungsten lamps are not such a problem for digital. The advantage of these lamps is that they show exactly where the light is going and what shadows will be produced. They don't need connecting to the camera so can be used with any make. The disadvantages are that the light is harsher and they put out a lot of heat so they are uncomfortable for models to sit in front of for any period of time.

Studio flash

For this you will either need a PC-sync socket on your camera (or a hotshoe adapter with a sync socket) so that a lead can be connected to the flash unit, or you should use an infrared transmitter on the camera, and a receiver on the flash unit to trigger it. These are a little more expensive than the simple flash lead, and are not available for every make of camera. The advantages of studio flash are that (with the addition of a reflector or softbox) it gives a much more flattering quality of light; the power can be controlled; it is much easier on any subject; and the units are quite cheap. It also offers immeasurably more creative control than any system fixed to the camera because the lights can be positioned wherever you want. You can use as many as you want because when the main light fires, slave sensors in the other detect it and automatically fire those as well. The ability to control the light and shadow areas with studio flash (and tungsten lamps) gives portraits a professional look, regardless of whether you are taking photographs for pleasure or profit.

finding subjects

One of the main problems for portrait photographers is finding people to take pictures of. The family network is usually the easiest place to start, as it may offer children, grandparents and young adults who could all make interesting subjects. Children are excellent for spontaneous poses, while older people, with their life story etched in lines on weather-beaten faces, make fabulous monochrome subjects.

models

Family and friends often make good subjects, but there will be a time when you want to widen the net in search of subjects. Some established photographers hand out business cards to people they see in the street; this approach works because they are well-known. If you aren't, and don't have a studio or a website to show off your work, then you will have to find another strategy.

Colleges are often a good source of potential subjects. You are far more likely to find interested subjects at an art or fashion college, so target which colleges you approach, either through message boards or the college website. Fashion students in particular will often be keen to swap time and modelling for promotional photos of their creations. In this case you may be able to avoid incurring costs.

If you need to use professional models, however, try looking up model websites on the internet. One very useful, international,

site is www.onemodelplace.com, which features models' advertisements. They have message boards so you can leave notes of any projects you have and invite interested parties to contact you. Mostly, you will have to pay the model for their time and travel expenses, but it is possible to find new models who are looking to build a portfolio. These will advertise themselves as available for work on a TFP (Time For Prints) basis. They usually like to have a CD as well. How many pictures you produce for the model is down to you, but twelve is a good starting point from which to negotiate.

If you have to pay for modelling time then bear in mind that the further away the model is from the location of the shoot, the more expensive the travel costs will be.

It is usual to pay for a minimum of a two-hour shoot, to add in travel expenses, and, if a model release form is required, to pay

extra on top. A model release form is simply a form containing the name and address of the model, the photographer's name and address, details of the photo shoot, and a paragraph assigning all copyright in the photography to the photographer. You might assume that the copyright is yours as the photographer, but this is in fact a grey area legally. If you intend to do anything with your photos, whether entering competitions or selling them commercially, you must have a model release form. How much extra on top the model will charge is negotiable; often they ask for two hours at whatever rate you are working at. If you state what the work is for, how much you are willing to pay, and that a model release form is required, then anyone who replies to adverts is fully aware of what they are going to be paid and you can avoid a costly surcharge.

! This is a sample rate guide per hour, for a reasonably experienced model, but one who isn't well-known or famous:

Fully clothed/Fashion: £30/$45

Swimsuit: £35/$50

Lingerie: £40/$60

Topless: £45/$65

Nude: £50/$75

1/ The internet offers a valuable resource for finding professional models.

2/ Family occasions and family members can offer the chance to capture portraits that are equally as memorable and captivating as the results of a formal session with a professional model. This charming picture of two young bridesmaids, Ellie and Georgia, was taken by UK photographer Helen Jones at her brother's wedding.

2 children and family

Images of children and of family members are among the most popular and accessible subjects for portrait photography.

This image of Shelley's son and his puppy was taken on a Canon PowerShot in black-and-white mode. The shot was captured on the spur of the moment when the two of them were together in the backyard. They both managed to keep quite still for the pose (unusual for both children and animals!) because they were tired from playing. Shelley managed to fill the frame effectively with the subject, so the image did not require any cropping. The whites of her son's eyes were brightened by sampling a bright area and using the paintbrush in Overlay mode. Finally, a little Unsharp Mask was applied.

My New Puppy by Shelley Sanders

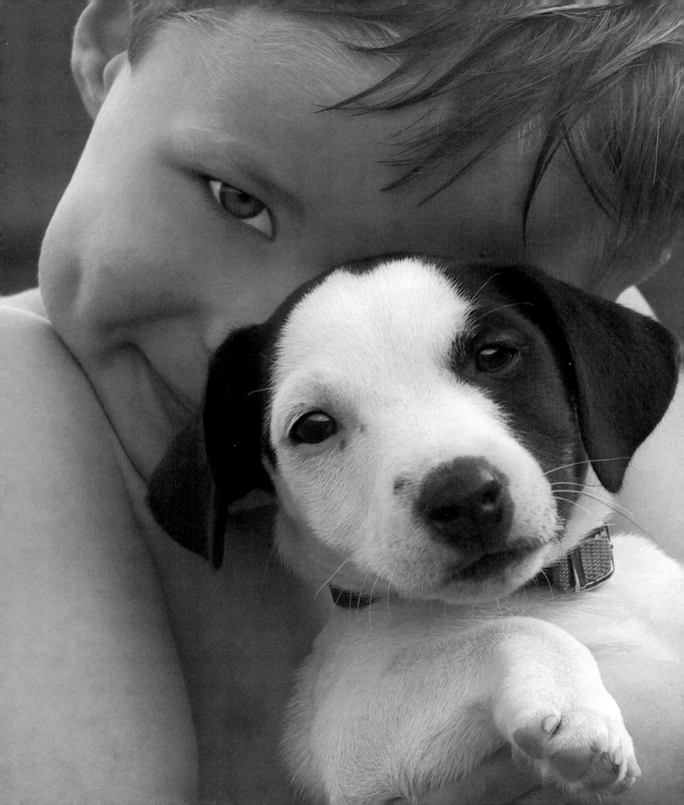

'Shooting digitally has rekindled my interest in photography...to the point of addiction.'

! Shoot in RAW mode if your camera supports it. This will allow a much greater range of tweaking possibilities later while retaining your 'digital negative'.

photographing children

Children are a great subject for photography, whether they are being quiet and thoughtful, playful and happy, or cheeky and mischievous. If you have children of your own, or in your extended family, another plus point is that they are readily available subjects with which to practise your photographic art.

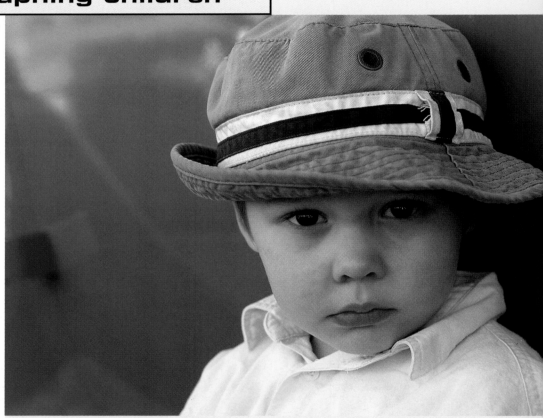

shoot

> JPEG data capture
> crop
> levels adjustment
> unsharp mask
> ink jet print

This photo was taken by Robert Ganz of Quebec, Canada. He had had his Canon digital SLR for a few weeks and was shooting in JPEG format (although he has subsequently moved onto shooting in RAW format as it offers better quality). While out on a walk with his five-year-old son, Robert spotted an antique car with a reflective blue finish that matched the thread in his son's hat. Robert asked him to sit down by the side of the car, and snapped away. He was using a 50mm, f/1.8 lens, which is a bright, or fast, lens. With the camera's focal length shift of 1.3x, this translated into a 65mm lens for the field of view – perfect for a portrait shot as it doesn't distort facial features.

! **Shoot, shoot, shoot.** You will improve your chances of success by taking lots of shots and not having to worry about the cost.

! **Experiment and review.** Try things that you would not normally do, and review the picture straight away to see if it works. Take advantage of the instant feedback that digital offers to refine your technique during the session. You will quickly learn what limitations and possibilities there are.

1 levels

enhance

After cropping, the image had its tonal range increased with Levels [1] and was given a subtle contrast tweak using Curves.

Unsharp Mask was then applied at just 125% [2], as Canon digital SLR images are naturally soft and so suited to portraiture. With this small amount of Unsharp Mask, the picture obtained enough sharpness without losing the pleasingly soft skin tones.

2 unsharp mask

enjoy

Robert's prints are made mainly for his personal enjoyment, although he sometimes enters them into competitions. On the subject of digital photography, Robert comments, 'I take a lot of children's photos, and always get results that please the parents, simply because of the immediate feedback on the LCD and because I can shoot literally hundreds of shots to get the keepers. Photo purists might scoff at this quantity versus quality approach, but I would argue that it is the result that counts, not how you achieve it.'

1/ Levels can be used to increase the tonal range of the image.

2/ Applying a small amount of Unsharp Mask helps to sharpen the picture slightly.

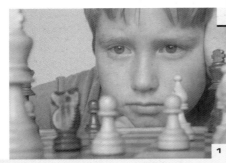

Heather McFarland of Michigan, USA, was watching her son learn to play chess with his father and saw him deep in thought. She grabbed her Nikon consumer digital camera and captured the scene to record the intensity and concentration on her son's face. She used an aperture of f/3.5 and a shutter speed of 1/30 sec.

candid portraits

One of the best ways of capturing children's expressions and poses is by not letting them see that you are taking their picture. Children often play up to the camera if they are aware of it and you will not obtain the shot you wanted. One solution is to use the zoom to get as close in to your subject as you can from the furthest distance away. Use the camera in Aperture Priority mode and dial in the widest aperture (the lowest number) available. This will throw the background largely out of focus and give you the fastest shutter speed possible. When using a zoom at full stretch, particularly indoors, there is a real chance of camera shake if the shutter speed isn't fast enough. Try to get a speed of at least 1/30 sec.

enhance

The image was changed to greyscale, and the tonal curve adjusted to give the image more contrast [2]. The image was cropped at the top and bottom of the screen to eliminate the edge of the chessboard.

2 curves

Channel: CMYK

Input: 20 %
Output: 16 %

1/ The original image before being enhanced.

2/ The contrast of the image was boosted via the Curves function.

> greyscale
> curves
> crop

enjoy

Heather makes prints both for her own enjoyment and for commercial sales. Since this is an image of her son, she wanted to reserve it for prints for her family and it has not yet been sold to any stock agencies.

For web use, Heather generally resamples her images to 480 pixels on the short side, then applies some Unsharp Mask. She generally sharpens in the range of Percentage 150, Radius 1 and Threshold 0. Each image will be a bit different, so you should use your judgement to avoid oversharpening. This results in unwanted halos, or white areas, around high-contrast parts of the image.

! Practise bracketing techniques. As you don't have to worry about film costs with digital, make sure you obtain the image you want. You don't want to find that the one or two images you took of a once-in-a-lifetime scene are so under- or overexposed that they are useless.

! Use your Level Equalisation and Curve tools. These are non-linear correction tools as opposed to linear tools like Brightness-Contrast-Intensity. Linear tools should be avoided when adjusting images because they do exactly the same thing to every pixel in the image, and pixels are lost at one or both ends of the tonal range.

! Join an internet photography critique site to submit your work and receive suggestions on how to improve it. Enter online photography contests to get your work shown and to see how you compare with other photographers.

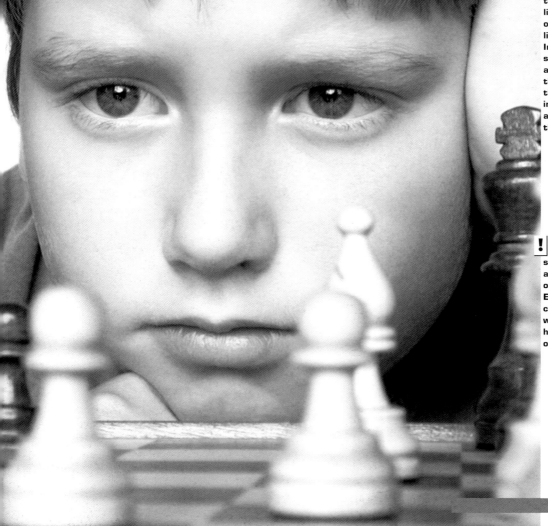

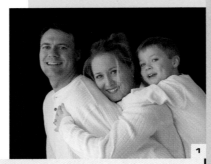
1

family portraits

The modern style of family portraiture is much more relaxed and informal than the best-shirt-and-tie, stiff-necked approach that was prevalent 30 years ago. It can still be described as formal portraiture, however, because such shots are deliberately constructed and posed. The key to this modern look is for the subjects to look happy and relaxed and the set-up to look informal and spontaneous (even if it's anything but!). If you want to be in the picture yourself and don't have anyone handy to press the fire button, then composition becomes very important, as does having a timed-release option on your camera.

> selective colour
> auto contrast
> clone
> healing brush
> burn
> paintbrush
> dodge
> motion blur
> unsharp mask
> brightness/contrast
> save

shoot

Shelley Sanders from Edmond, Oklahoma, shot this portrait of herself, her husband and her son on her Canon PowerShot in black-and-white mode. 'Just the Three of Us' was the family's first official portrait. Shelley decided that the look should be fun and modern, not stiff and serious. She set up a black backdrop in the family's kitchen, dressed everyone in off-white shirts and set the camera on a tripod with a timer. She had two poses already thought out, and this one worked the best with the light. It took Shelley about ten shots over 30 minutes to capture this result – although it took weeks to persuade her husband and son to agree to pose for it!

! Concentrate on using light and how it falls across the subject to make the difference between a stunning photo and an ordinary photo.

1/ The original image.

2/ Selective Colour and Auto Contrast were used to enhance contrast.

3/ The Clone tool was useful for improving skin texture.

4/ The Motion Blur filter was used to smooth out paintbrush marks in the whites of the subjects' eyes.

5/ The final step was to adjust Levels.

enhance

First of all, the image was given more contrast and impact by using Adjustment > Selective Colour and selecting Neutrals [2]. Then the contrast was adjusted by using Auto Contrast. The strength of automatic functions can be adjusted by selecting Image and then Fade from the drop-down menu.

Then the Clone tool [3] was used with a low opacity to clean up age spots and smooth away wrinkles with nearby sources of smooth skin that matched the tone and texture of the area. Photoshop 7 has a Healing Brush tool, which is pretty much an automated clone tool; this tool was also used to clean up the subjects' complexions.

The next stage was to brighten up the eyes. The Burn tool was used to darken the shadow detail areas such as the pupils and eyelashes.

2 selective colour

Colors: Neutrals

Cyan: 0 %

Magenta: 0 %

Yellow: 0 %

Black: -11 %

Method: ○ Relative ● Absolute

3 clone tool

History | Actions | Tool Presets

familyoriginal.tif

Selective Color

Auto Contrast

Clone Stamp

Clone Stamp

Rectangular Marquee

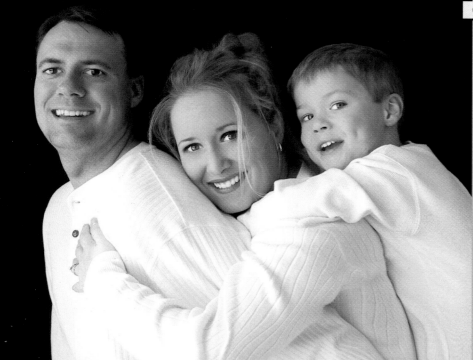

Most of Shelley's family shots are meant for her family only, but some are used as stock images by photo libraries. Shelley scales down her shots to smaller versions for use on the web and for emailing to relatives.

! A dark-haired person can easily merge into a dark background if too much Levels adjustment is used. One way to avoid this is to dodge some highlights into the hair before you use Levels.

! Always shoot using the largest file size in the best quality mode you can. This maximises the image quality, and you never know when you might need a picture just like the one you've taken. A low-resolution file won't be usable for anything else.

Then the Eyedropper was selected and the brightest area in the catchlight of the eye sampled. The paintbrush was used, in Overlay mode, to paint the white of the eye. Once it looked bright enough, the Dodge tool, in Highlight mode, was used to brighten the catchlight and iris of the eye. Finally, the white of the eye was selected with the Marquee tool and the Motion Blur filter used with a percentage setting of 200% [4]. This smoothed out the paintbrush strokes from the overlay process.

The last step was to globally adjust the sharpness and levels of the photo. As with most digital images, Unsharp Mask was a must. Do not overuse the

4 motion blur

200%

Angle: -82

Distance: 4 pixels

OK
Reset
Preview

5 levels

Channel: RGB

Input Levels: 16 1.00 255

Output Levels: 0 255

Unsharp Mask filter, as it produces a glowing line around the subject or, if you are using the Sharpen filter, a jagged line in place of your once curved lines. After sharpening, the Levels were adjusted [5] to darken the dark areas of the

photo slightly. Finally, the contrast of the image was slightly increased and the brightness slightly decreased to avoid washing out the bright areas.

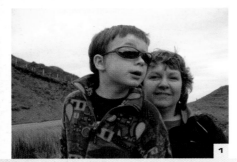

1

family on location

! Put your camera in Aperture Priority mode and select the lowest f-stop number to produce the minimum amount of depth of field. If there is still too much background in focus, blur it later on the computer.

Family holidays are a staple subject of photography. But following some simple guidelines means that you can transform such images into something more than just holiday snaps. Be aware of lighting conditions and avoid basic mistakes such as shooting directly into the sun. If you put the camera on the widest aperture setting, or in a portrait mode, you will generally avoid having the background merge with the subjects. Try to capture family members when they are behaving naturally rather than posing self-consciously.

> crop
> gaussian blur
> clone
> diffuse glow
> eraser
> interpolation
> print

shoot

My daughter Chloë took this photo of her brother and mother with a Fuji entry-level consumer digital camera while on holiday on the Isle of Skye. Jacob had grabbed hold of my sunglasses to try them on. The combination of elements – the sunglasses being too big for Jacob; the pose he assumed as he was looking around wearing them; and the position of his mother in the background – made for a memorable family portrait.

enhance

The problem with the Fuji camera is that it tends to produce more depth of field than you might want. However, the first task was to crop the picture to concentrate on the interesting elements.

To separate Jacob from the background, a duplicate layer was created. This then had a Gaussian Blur applied [2] with a radius of 8 pixels. Then the Eraser was used to remove the subject [3]. A feathered brush was used to allow the edges of the child to take on a softer look, except for where his face and his mother's overlapped. Here, a hard-edged brush was used. The layers were then combined.

Some cloning work was done on Jacob to remove food crumbs from his clothes,

2 gaussian blur

OK
Cancel
☑ Preview

50%

Radius: 8.0 pixels

> **!** Consider your composition. Try to capture people in a three-dimensional space, rather than simply standing in a row.

1/ The original photo had too much depth of field; the subject had just finished eating so had crumbs everywhere; and his mother had no make-up on!

2/ Applying the Gaussian Blur filter.

3/ Using the Eraser tool to remove Jacob.

4/ The Diffuse Glow filter adds radiance and grain to the image.

enjoy

As well as being interpolated up in size to make it usable for commercial reproduction, an A4 print of this image was made on a Canon photo-printer at 300dpi. This then went on display at Chloë's school.

3 eraser

4 diffuse glow

and then a duplicate layer was created again. The Diffuse Glow filter was used to give the image a white glow and to add some grain [4]. Small parts of the top layer were then erased in the sky region to stop it being uniformly white. The layers were then flattened.

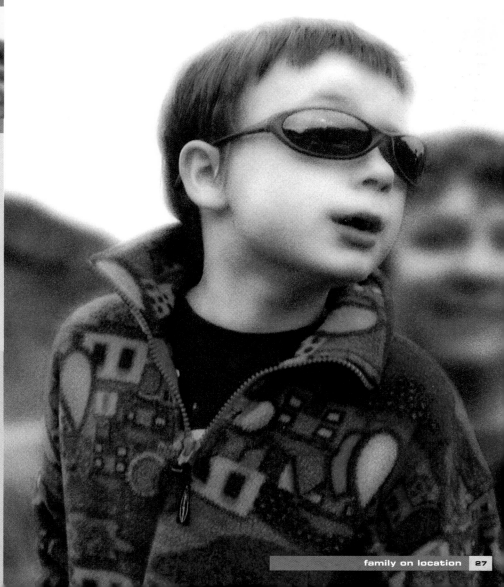

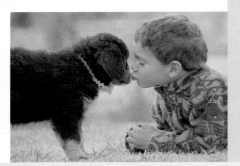

! The two most common colour spaces are Adobe RGB and sRGB. The former has a much wider colour gamut and is thus better suited where the image is going to be commercially printed after conversion to CMYK. On the other hand, sRGB has a smaller colour gamut, but more accurately reflects the characteristics of PC monitors.

family pets

While taking photos of animals doesn't quite qualify as portraiture, capturing the family pet playing with children certainly does. You could create a formal shot with the child and the pet posing together side by side. The advantage of this is that you can control the lighting and create the look you want. The drawbacks are that such shots can look stilted and that few pets – or children – sit in one spot while you sort out backgrounds and lights. Candid photos of children and animals at play, by contrast, contain a natural animation, excitement and joy – your job is simply to capture the moment.

shoot

Darwin Wiggett of Alberta, Canada, took this photograph of his son playing with a Bernese Mountain Dog puppy using a Canon EOS-1n 35mm film SLR, Canon EF70-200 f4.0L lens and Kodak Supra 100 print film. The print film was scanned using the Adobe RGB colour space.

This is a classic child-and-puppy shot, but, in order to obtain it, Darwin had to resort to photo-editing.

enhance

Darwin used two photos to achieve the final result. One had the puppy looking straight forward [1], and another had his son facing forward [2]. After scanning, both images were loaded in Adobe Photoshop and composited together as separate layers, using a layer mask to blend them together [3]. The advantage of using a layer mask was that the transition from one photo to another could be done with gradual opacity, thus avoiding a join and the all-too-obvious 'stuck-together' look.

1/ Invariably as the boy leant forwards to kiss the puppy, it would turn its head away. The solution was to take one photo of the dog...

2/ ...and another of the boy...

3/ ...and blend them together in Photoshop.

> film capture
> scan
> layer masks
> print

! When shooting the interaction of child and pet, stay back and use the zoom to get close in so you don't distract them.

! Shoot using the widest aperture. You will rarely want a tightly focused background, while the increase in shutter speed will help avoid camera shake when using the telephoto zoom.

enjoy

The film was scanned at a high-enough resolution so that, when the final image was created, it could be commercially printed at 300dpi, up to a size of around 15 inches by 10 inches. The other advantage of scanning at such a resolution is that it made the image usable for stock photography agencies. Bear in mind that this image comes from two shots – scanning one frame of 35mm print film at such a resolution is likely to be a waste of file space as beyond a certain level there is no more detail to be found.

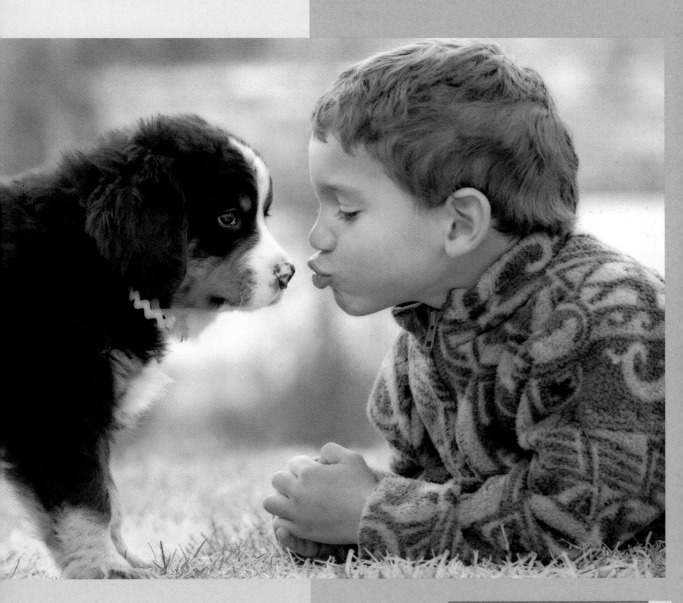

! Try to make the photo as good as possible when you take the shot: a better starting shot will get you a better end result. Don't take one shot and spend ten hours with image-editing software – take 100 shots and spend ten hours with software.

1/ The original image, straight from the camera.

2/ Cropping gives the shot greater impact.

3/ Converting to monochrome complements the subject.

4/ Adjusting brightness and contrast and adding a grain effect introduces extra atmosphere.

5/ The finished result, with a sepia effect.

older people

Older family members can make excellent portrait subjects. Black and white is the preferred medium: the viewer can concentrate on the texture, the character and all the lines and creases of the face. You don't want soft focus and disguised lighting: make your photos as sharp as possible to reveal every trace that time has left.

shoot

The subject of this portrait, Agne, is a relative of Hans Claesson of Norway, who took the photograph with his Olympus consumer digital camera. Hans was documenting Agne's garden work, without any real intention of turning the resulting shot into a portrait. However, Hans liked Agne's expression so much that he decided to use photo-editing software to turn the shot into black and white and enhance it.

> crop
> blur
> paint
> greyscale
> clone
> dodge and burn
> brightness/contrast
> grain
> light effect
> save and print
> prepare for web

! Play around a lot, but remember that other people only see the end result and not how much fun you have had or how much you have learned. Applying various filters and actions can amuse you and be great fun, but to another viewer those filters could be destroying the photo.

! If you are doing cut-and-paste composites from numerous images, take the photos at the same time with the same lighting. Be thorough with edges when you cut and paste or select and change colour, or the result will look unprofessional.

enhance

The process was started by cropping off extraneous material around the edges [2]. The subject was selected using the Marquee tool and the edge feathered to make it smoother. The selection was saved. A duplicate layer was created with Gaussian Blur applied. Using the selection, the blurred version of the man was erased, with work being done carefully around the edges of the hair. The layers were then merged together. A new layer was created, and the colour blue selected and used to spray a bottle shape onto the hat.

The image was converted to greyscale [3]. The Clone tool was used to tidy up small amounts of detail and the Dodge and Burn tools used to correct overexposure and to add shadows where necessary.

Next, the eyes were selected and brightened [4] and the overall brightness and contrast were adjusted. Then, an extra layer with a grain effect was overlaid to give the image more roughness.

A new layer was created and the Lighting Effect filter used to make the centre of the image and the face a little brighter and the rest of the shot darker. The layer opacity was reduced to avoid overemphasising the effect. The layers were then merged. The image was converted back to RGB and the Curves control used to adjust the separate Green and Blue channels. These were used to give the image a sepia effect [5].

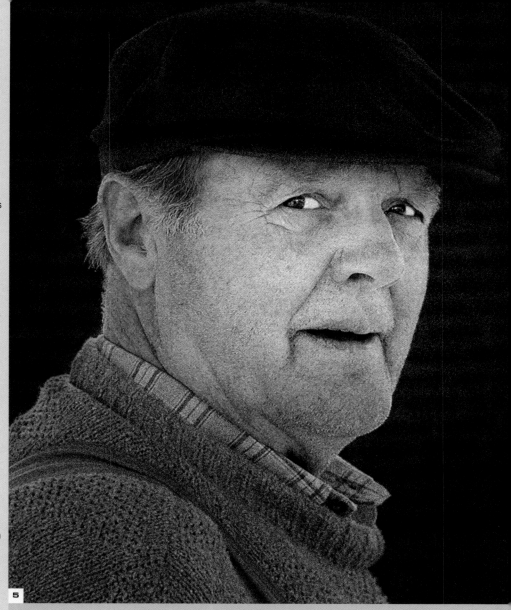

5

enjoy

Initially, this photo was produced and printed only for Hans' personal enjoyment. Hans intends to use it as part of an online exhibition entitled 'The Working Man'. Preparing the image for web use is something that takes place after all the other work and simply involves reducing the resolution and, consequently, the file size.

3 studio portraits

The studio setting allows you to control the lighting and the environment to create expressive and evocative portraits where the subject's personality shines through.

This shot by Caesar Lima perfectly illustrates the advantage of shooting in a studio. The key light is off to one side of the chiselled-looking model, allowing shadows and highlights to pick out his impressive musculature. Control of the white balance ensures that the background is rendered as pure white, forming a stark, contrasting black-and-white image.

Bostrom by Caesar Lima

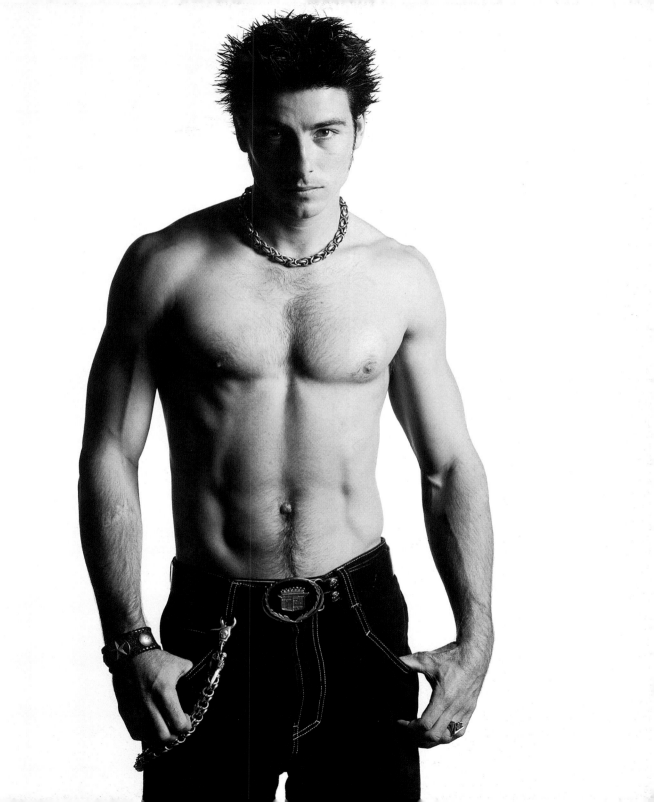

1

! It is best to start with good colour balance at the beginning of the shoot than struggle with making adjustments post-production. Many cameras have several colour balance options and some allow you to fine-tune the colour balance in the camera. One way to do this is to photograph a McBeth colour chart or grey card before the shoot at different colour balance settings and compare them in Photoshop to find the optimal settings. This approach helps to eliminate or vastly reduce post-production colour balance adjustments.

classical portraits

The classical portrait is the mainstay of high-street photographers specialising in shots of babies, newly engaged couples and family groups. An evenly balanced lighting set-up is an essential component of such a portrait.

Another key factor in creating a successful classical portrait is your interaction with the model. If the model is inexperienced, he or she will require guidance and feedback as to what poses and expressions work well.

shoot

The subject of this shot, Chelsea, was 13 years old and interested in pursuing a modelling career. Her mother approached Marc Jaffe of Pound Ridge, New York, about taking portraits for a portfolio to take to modelling agencies. Jaffe set up a 10-foot-square hand-painted muslin background and used a classic portrait lighting set-up for the shot: a Sunpak 622 Super Pro flash head with a Quantum turbo battery as the key light, and a Quantum Q-flash Turbo T 150W flash head with a second Quantum turbo battery as the fill-in light attached to two professional studio umbrellas. The lights were metered so that the fill light was 50% of the key light. No fill cards or bounce lighting were used. Chelsea had had no training in modelling and no experience in front of the camera. However, the Olympus digital SLR used has a video out connector, so the camera was hooked up to a TV set, which enabled Chelsea to see a live preview of the shot and adjust her position accordingly. This strategy was very successful – Chelsea quickly evolved during the shoot from the pretty teenager smiling for a snapshot in the 'before' image [1] to the demure, mature-looking model in the final shot [2].

! Avoid over-sharpening images in post-production, since it adds an unnatural look and degrades the image. Make all adjustments to the image before sharpening. The sharpening effect should be the last adjustment made prior to saving for output of any kind.

enhance

This image required only minor adjustments to the contrast and brightness. First, an adjustment layer was created in Photoshop 7 for Levels. Auto Levels were used because the default settings appeared acceptable at first [3].

However, when applied to the image, the effect was too pronounced. Therefore the opacity of the adjustment layer was reduced to approximately 50% until the result was deemed acceptable.

> auto levels
> brightness/contrast
> opacity
> model portfolio
> resize for web

3 auto levels

Channel: RGB
Input Levels: 0 1.00 255

OK
Cancel
Load...
Save...
Auto
Options...

Output Levels: 0 255

☑ Preview

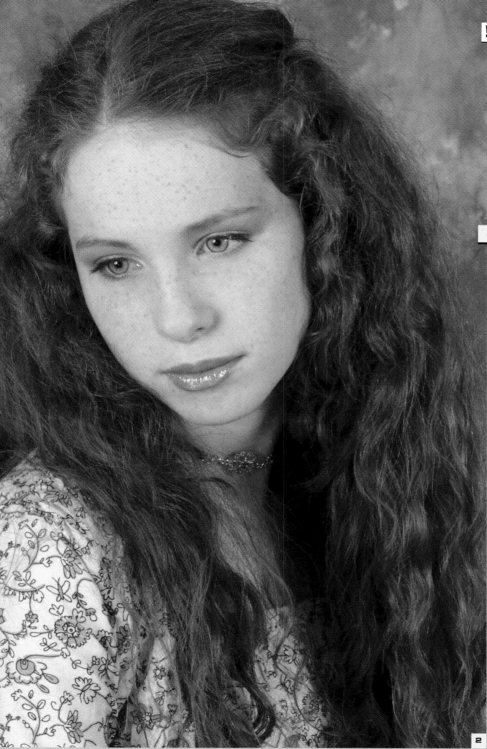

enjoy

Marc primarily creates fine art digital landscapes and equestrian imagery for exhibition and sale at art galleries, as well as on his website. He takes digital portraits on rare occasions, primarily for personal use. To prepare images for the web, he resizes them to fit the web pages, which is generally 320 x 240 pixels. Prior to exporting the images to JPEG format, he applies a standard Sharpen filter, and, if necessary, adjusts and fades back any over-sharpening with the Edit > Fade Sharpen command. This is much easier than the Unsharp Mask command. He then saves the images as a 60% quality JPEG, which is a good compromise between image quality and file size.

1/ The initial photo shows the 13-year-old would-be model smiling for the camera with little idea of posing.

2/ Once made up and able to see the live feed from the digital camera, the subject learned rapidly about what poses and expressions worked well.

3/ The image was basically good from camera, with only minor adjustments needed to the brightness and contrast.

2

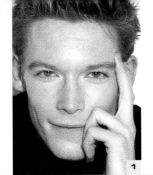

1

! When taking a head shot, try to use only one light, or natural daylight from one direction, so that shadow detail can be applied to the face.

head shots

Head shots are a key staple of the studio portrait photographer. Such portraits can be very effective because the sole focus of the image is the subject's face, often making direct eye contact with the camera. Such images are often expressive of the subject's personality, so composition and expression are therefore vital components for a successful shot.

shoot

This was a typical studio head shot and could well have been created with expensive lighting and a serious amount of camera kit. However, the subject, Toby, needed pictures for his acting portfolio and had only a limited budget. Helen Jones of London, UK, was happy to oblige with her Nikon consumer digital camera and a shoot that was set up in her front room. Using diffused lighting from a window and careful composition, she shot the image in black-and-white mode.

enhance

The image was initially cropped to provide a tighter focus on the face [2]. Then the background layer was duplicated. The duplicate layer was blurred and the blend mode changed to Overlay [3]. This added shadow and tonal detail.

A little Unsharp Mask was applied to slightly sharpen the image, and the Burn tool was used to increase the impact of the eyes and hair. A brightness/contrast layer was used to increase the contrast. Finally, a border was added by making the background colour black and increasing the canvas size by 1cm.

2 crop

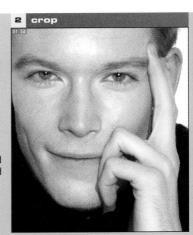

3 blur layer

> crop

> duplicate layer

> blur and overlay mode

> unsharp mask

> burn

> brightness/contrast

> border

> print

! Only use a twin flash head set-up if you want a completely evenly lit portrait, or if doing a group shot where one light will not be strong enough.

1/ The initial shot.

2/ Cropping tightly into the subject's face gave the image more impact.

3/ A blur layer added more tonal detail.

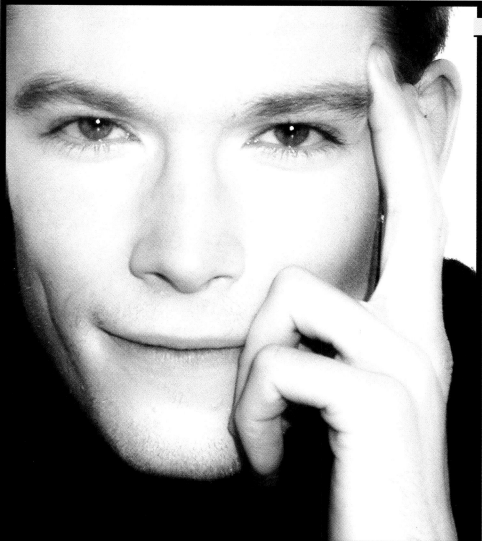

enjoy

As this was a commission, done on a budget and needed in a hurry, Helen sat down with Toby after the shoot and digitally enhanced the picture as described, there and then. After the editing was complete, she printed the photo out on an ink jet printer and saved the image to a CD for Toby to take away.

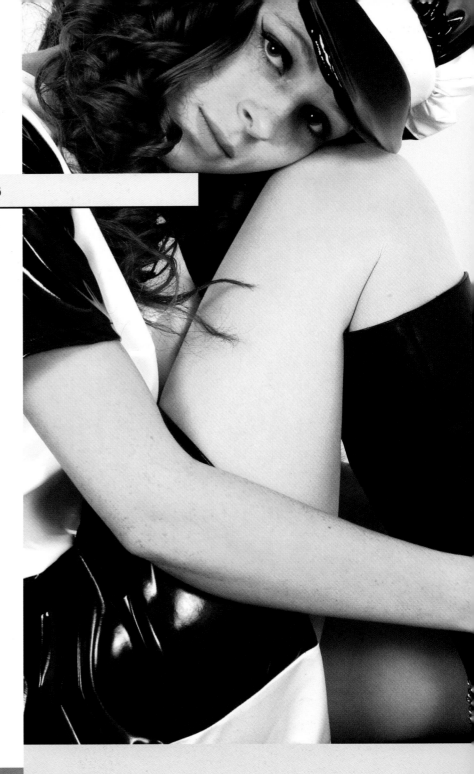

radical poses

Studio portraits do not have to be serious and formal. There is plenty of opportunity to ask the subject to pull wild poses and dress up in unusual outfits. These should, however, suit the subject and not make them look silly. The idea is to complement their character. This concept works particularly well where the subject is known for a particular dress style or character trait, as it helps convey their personality. Some of the best portraits are those in which the subject is allowed to express themselves fully. David Bailey is a master at achieving this – see his portraits of Mick Jagger and Gerard Depardieu in the books *Archive One* and *Chasing Rainbows*, where the integral character of the subjects shines through.

> levels

> hue/saturation

> magazine repro

> alternative

> variations

> curves

shoot

The subject of this picture loved 1960s' style clothing and, with her slender figure and masses of curly hair, could have passed for a Twiggy or a Jean Shrimpton in years gone by. For her portrait, we hired a 1960s' Mary Quant PVC dress from a costume shop, complete with matching hat. Two flash heads were used to provide even and full lighting from behind and from the left and right of the camera. The camera used was an Olympus digital SLR, shooting at f/11 in order to maximise sharpness across the subject. A tight crop was used to frame the subject and she assumed a 1960s' elfin-like pose, with her arms and legs providing diagonal reference points.

> **!** Flash, even fill-in flash, will make a **PVC** outfit shine in a way that natural light won't.

enhance

The contrast range of digital cameras is slightly limited compared to film. While the model came out quite nicely with the exposure, the background was exposed as an off-white colour. One way to brighten it up and enhance the white tones was to use Levels [1] and to drag the right-hand slider inwards, without discarding all the data where the spike appears. By tweaking the levels, the whites became pearly-white and the image was brightened in general.

The Hue/Saturation [2] control was then used to increase the colour throughout the image. The Olympus digital SLR gives naturally very neutral colours, and they sometimes need to be boosted at the photo-editing stage. When increasing saturation in portraits it must be done only in small increments or with targeted colour channels to avoid giving the subject an unpleasant complexion.

> **!** To get a brighter subject when shooting with studio flash, if the meter reading says f/11, drop the camera setting to f/8 in manual mode.

enjoy

This image was used in a magazine feature. The repro was only a quarter-page image size so it was able to be used at 300dpi, which is the commercial picture density standard. At A4 the dpi would fall to around 220, which might then require a subtle amount of interpolation to bring the print resolution up to 300dpi for commercial reproduction.

For personal pleasure, a further variation on this picture was created [3]. The image was desaturated, and then Curves was used to dramatically enhance the contrast, pushing the extremes of the image right up to the point where detail would be lost.

1/ Levels was used to brighten the white tones.

2/ Hue/Saturation helped to boost the colours in the image.

3/ This mono alternative used Curves to stretch the tonal range until detail started to disappear.

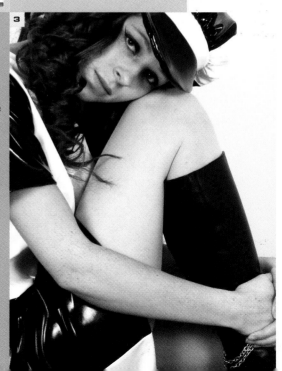

1

'I believe that the biggest challenge is to take a great photo with a digital camera where no one can believe that it's only a Canon PowerShot, not a Nikon with super lenses.'

fashion shots

Experimenting with the styles and techniques of fashion photography will give your portraits a more cutting-edge feel. Fashion photography is about attitude and lighting. It means encouraging the subject to be expressive, sultry and feisty. Lighting should be adventurous, either throwing shadows around, or covering the subject with colour. The legendary fashion photographer Helmut Newton once remarked that he only liked dangerous women. That's the kind of look and feel you need to aim for: portrait photography, but with attitude.

> duplicate layer

> multiply blend mode

> burn

> black added

> contrast

> red channel desaturated

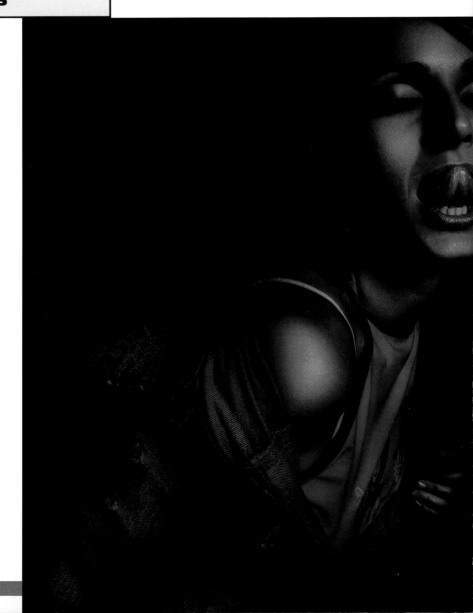

shoot

Zosia Zija of Warsaw, Poland, took this shot of her friend Sylwia, who is a model. Zosia was used to traditional analogue cameras and was trying to achieve similar effects in digital portrait photography. She was trying to prove to her colleagues, who are very traditional, that digital images could be interesting and not have the typical, flat, clean digital look. This shot, taken on a Canon PowerShot, was part of a session held in Zosia's private studio. Zosia used a softbox flash for lighting. It was Sylwia's first photo session, so she was quite nervous at the beginning, but during the session she relaxed and the all-important attitude shone through.

! **Portrait photography is all about light. Adjust your setting to natural light or use studio's flash lighting. And just take shots.**

2 multiply blend

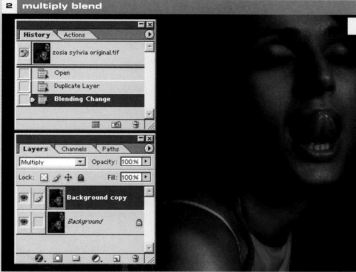

enjoy

This image was created as part of Zosia's personal digital portrait project, but was also used in a local exhibition of her prints. She prepared the image for web use by adjusting the resolution to 72dpi. She comments on the advantages of digital photography: 'the best part is that, if you are not completely satisfied with your shot, you can just delete it and take a better, more interesting, picture. I believe that the biggest challenge is to take a great photo with a digital camera where no one can believe that it's only a Canon PowerShot, not a Nikon with super lenses.'

1/ The original image.

2/ The shot was darkened using Multiply as the blend mode.

3/ The image was desaturated to give it a more moody, sultry atmosphere.

enhance

The image was enhanced in Adobe Photoshop. Duplicate layers were created and the blend mode changed to Multiply [2] to create a darker image. Burning was used on overexposed areas. The colour was adjusted by adding black, then the contrast was tweaked and the red channel desaturated [3].

3 desaturate

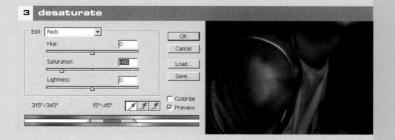

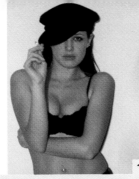

1

striking colour

Novice photographers are often advised to start off learning their craft with black and white. The reason is not that it is any easier to make great monochrome photos, because it isn't. The reason is that it is easier to create acceptable photos in mono and avoid making awful colour pictures. Using colour in portraits brings its own unique challenges. Colour imbues an image with a subtext, and capturing just the right shade, brightness and consistency, particularly with mixed lighting sources, can challenge the most experienced professional.

shoot

London-based photographer Helen Jones was commissioned to produce 100 images to be used for a New Year's party, called 'Saints & Sinners', at Soho's Mezzo restaurant. The images were to be projected on the walls and used on the menus and the event's publicity flyers. Helen used a professional model, Samantha Mason, for this shoot. Helen likes to use models with strong personalities who are able to convey the mood she is looking for. She also finds that actresses often make fantastic models for her art pieces. A Nikon consumer digital camera was used with one light to create the basic image.

enhance

Helen took a picture of Samantha that was slightly out of focus and used the maximum Levels settings in the Unsharp Mask filter in Photoshop [2]. If the picture is already sharp, the effect is quite different and not as desirable. In line with the commission, the picture was supposed to have a sexy

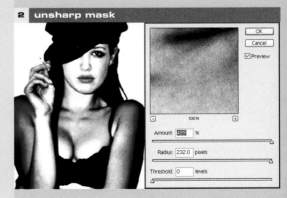

2 unsharp mask

1/ Original image.

2/ Applying the Unsharp Mask filter put some bite into the picture.

3/ The vibrant, striking colours were created via the Channel Mixer function.

> unsharp mask
> channel mixer
> print

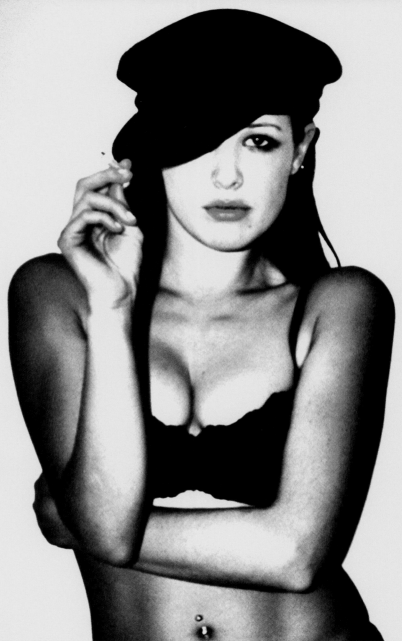

feeling and the smudged look around the model's eyes enhanced that type of sultry look.

The Channel Mixer function was then used to create the strong colouring by altering the colours in each separate channel [3]. This can be used to colour tone a picture without affecting any of the luminance detail.

3 | **channel mixer**

Output Channel: Blue

Source Channels

Red: 0 %

Green: 0 %

Blue: +74 %

Constant: 0 %

☐ Monochrome

OK
Cancel
Load...
Save...
☑ Preview

enjoy

This print was commissioned as part of a series for Mezzo, which is Conran's largest European restaurant based in the middle of Soho, London. The print is available for sale as a limited edition and is offered in various colours.

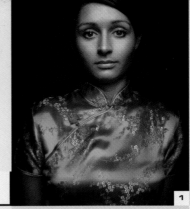

'Digital photography is great. It's fast and easy. You don't have to worry about running out of film in the middle of your session. You don't have to worry about overexposing your negatives.'

subdued colour

By removing most of the colours from a photo and leaving just one main hue, you can create very atmospheric portraits. The model should assume an understated, subtle pose to complement the colour treatment. The use of wide apertures to limit depth of field is also a good idea, and lighting should be sparse so that only the subject, perhaps with certain vague elements of the background, is illuminated.

1

shoot

This shot, by Zosia Zija of Warsaw, Poland, features the use of tightly reined-in colour to great effect. It was taken on a Canon PowerShot digital camera, fitted with an adapter in order to use a studio flash head with a softbox attachment to create even, flattering light. The model, Sylwia, was fairly inexperienced, so this subdued pose was easy for her to assume.

enhance

A duplicate layer was created [2] and the blending mode set to Multiply. This has the effect of making a photograph darker, but in a way whereby the darker areas tend to become blacker. The Burn tool was used to correct overexposed highlights. The colour balance of the photo was then adjusted by increasing the amount of black in it, and the contrast was adjusted.

Finally, the Hue/Saturation control [3] was used. The colour picker selected the red of Sylwia's dress and this was then reduced in saturation. The effect was to darken the entire image, leaving only the subtle reds of the dress to match the subdued pose and atmosphere.

2 layers

3 hue/saturation

enjoy

Zosia had been working on a digital portrait project to convince traditional film users that digital can achieve the same kind of subtle tones that film can. This image was created for her exhibition showing just that. It was also edited for use on websites by resizing the print density to 72dpi and resampling the image. This reduces the actual resolution: if the resampling option were not used, the picture would retain the same resolution.

> duplicate layer
> burn
> increase black content
> hue/saturation
> print
> resize for web

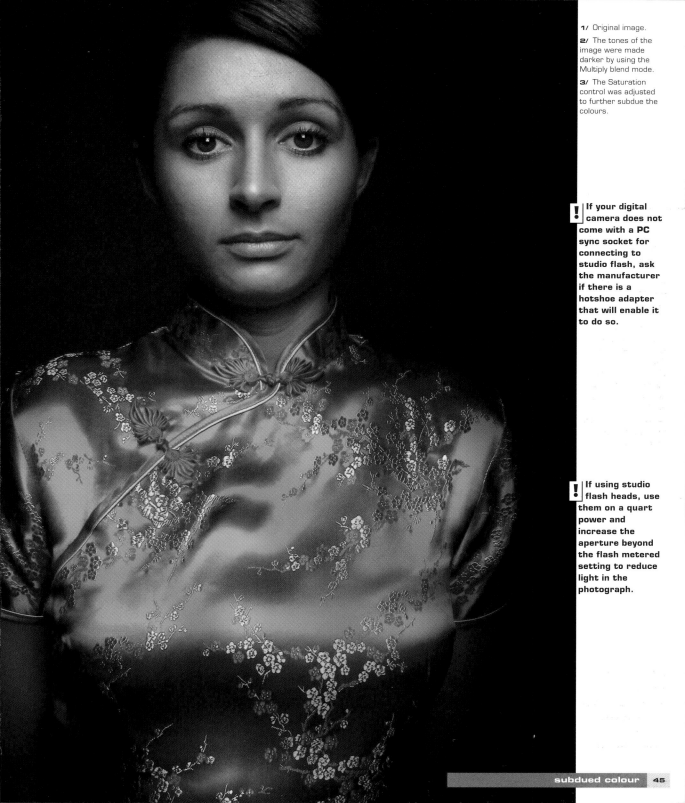

1/ Original image.

2/ The tones of the image were made darker by using the Multiply blend mode.

3/ The Saturation control was adjusted to further subdue the colours.

! If your digital camera does not come with a **PC** sync socket for connecting to studio flash, ask the manufacturer if there is a hotshoe adapter that will enable it to do so.

! If using studio flash heads, use them on a quart power and increase the aperture beyond the flash metered setting to reduce light in the photograph.

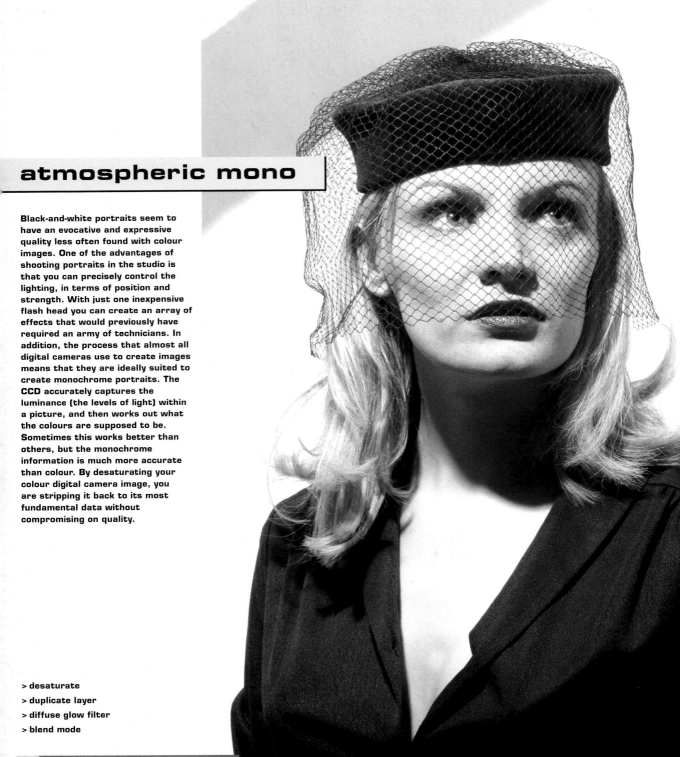

atmospheric mono

Black-and-white portraits seem to have an evocative and expressive quality less often found with colour images. One of the advantages of shooting portraits in the studio is that you can precisely control the lighting, in terms of position and strength. With just one inexpensive flash head you can create an array of effects that would previously have required an army of technicians. In addition, the process that almost all digital cameras use to create images means that they are ideally suited to create monochrome portraits. The CCD accurately captures the luminance (the levels of light) within a picture, and then works out what the colours are supposed to be. Sometimes this works better than others, but the monochrome information is much more accurate than colour. By desaturating your colour digital camera image, you are stripping it back to its most fundamental data without compromising on quality.

> desaturate
> duplicate layer
> diffuse glow filter
> blend mode

> To get a 'cleaner' look to the model, shoot at a lower f-stop than your metering suggests. If it says f/11, shoot at f/8 or f/5.6 to tread close to burning out detail without actually doing so. If you are shooting on film and then scanning the image, use a higher-rated ISO film: the larger grain will give a smoother complexion under strong lighting.

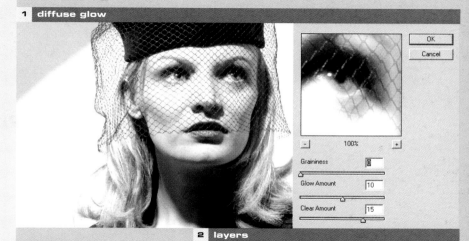

1 diffuse glow

shoot

The model posed against a white wall in front of an arch in the studio room. The arch adds some subtle visual background interest. The lighting and look of the image are classic 1930s-style (although the pose is more 1940s' film noir, as is the model's dress). This lighting effect is called loop lighting, for which you need to strip your flash head down to the basics. Get rid of the reflector, diffuser, softbox etc., and position the flash head at a 45-degree angle above the model, pointing down and at 45 degrees away from the centre of the face on the horizontal. The light is then high and to the left or high and to the right of the subject, resulting in the desired effect of harsh light and distinct shadow.

enhance

The image was desaturated to turn it into mono (it wasn't turned into a greyscale because this means that you are unable to perform certain editing functions on the image). To create the pure white skin and film-star sheen to the portrait, a duplicate layer was created and the Diffuse Glow filter applied with settings of zero for Noise, 10 for Glow and 15 for Clear Areas. I experimented with the blend mode to get the best effect, trying out Screen and Lighten. As these didn't look quite right, I simply set the blend mode to Normal, and reduced the opacity to combine the two layers.

2 layers

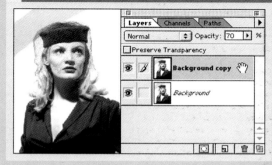

The glowing, ethereal layer was combined with the original layer, which had more detail and texture.

enjoy

This image was originally shot as part of a magazine feature, but was not used because of space and editorial considerations. However, it has been printed out on ink jet at up to A3 at 150dpi and currently resides on the wall of my photographic studio. Be aware that reducing the overall size of the image for display on the web or email will lose almost all the texture, so this should only be done where quality is not a consideration.

1/ Using the Diffuse Glow filter helps to create a luminous, Hollywood-star sheen to the subject's skin.

2/ The new layer was blended into the original by adjusting the opacity.

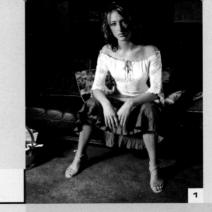

! Ensure that the subject has enough light, even though you are concentrating on creating shadow detail.

1

mood shots

shoot

enhance

There are many moods and styles of photography that you can experiment with when taking portraits. Having your subject look happy, excited or engaging with the camera is one approach. Another approach borrows the attitudes and styling from much of today's fashion photography: the moody, sultry look. Atmospheric lighting is required to create this look. Bright, even lighting, coupled with a sulky-looking subject would create an incongruous result. Instead, use natural light, fill-in flash, or just a single main flash head to generate shadows.

> duplicate layer

> multiply blend mode

> eraser

> curves

> burn

> save as **TIFF**

> save as **JPEG**

I shot this fashion-style photo for a magazine feature, using an Olympus digital SLR and a portable flash head with an umbrella. Normally I would use a softbox, but I wanted the light to be harsher in this case. The studio location was my lounge. There was natural light coming through the large windows in front of the model, but it was too uniform and direct, as well as too bright – hence the use of flash. The flash was placed to the left, while a reflector to the right ensured that detail was available on the darker side of the photo. The flash and camera were set to f/11, which was the maximum output and aperture available. A large flash and camera like a Fuji digital SLR would have produced a narrower aperture like f/22 and really plunged the background into darkness. The meter reading gave the background at f/4 at the flash sync speed of 1/125 sec, so I knew that the background would be subdued but still visible. Accepting the limitations of the equipment, the solution would come later on the computer.

The model's pose was fine, but the background was far too bright [1]. A duplicate layer was created and the blend mode set to Multiply [2]. This darkened the entire image by multiplying the contrast. However, the effect on the face, shirt and legs, where the exposure was fine, was too severe. The answer to this was to use the Eraser to rub away at those areas on the top layer, thus exposing the layer underneath.

The layers were blended together and then the Curves function was used [3]. Two points were placed at the centre and a high point, locked onto the middle of the diagonal line to ensure that they did not alter when the lower portion of the curve was lowered. This made the darker areas darker still, introducing shadows and removing extraneous detail.

To finish off, the Burn tool was used to knock back the cushion behind the model's arm, the carpet, and other areas where highlight reflections were still showing.

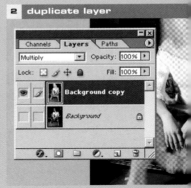

2 **duplicate layer**

1/ The original photo shows too much background because the camera and flash were not powerful enough.

2/ The tone of the shot was darkened by setting the blend mode to Multiply.

3/ The Curves function was used to make the image even more moody and dark.

If shooting in a room with a flash, use a narrow aperture to make the background darker. If shooting without flash, use nets to diffuse the natural light and reflectors to direct it.

3 curves

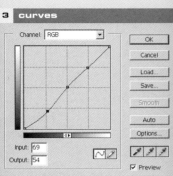

Channel: RGB

OK
Cancel
Load...
Save...
Smooth
Auto
Options...

Input: 69
Output: 54

☑ Preview

enjoy

This image was saved as an uncompressed 300dpi TIFF and was used in the magazine for the feature mentioned. It was also resized to 640 x 480 and 160 x 120 for use on the web and saved as a JPEG file to minimise the size.

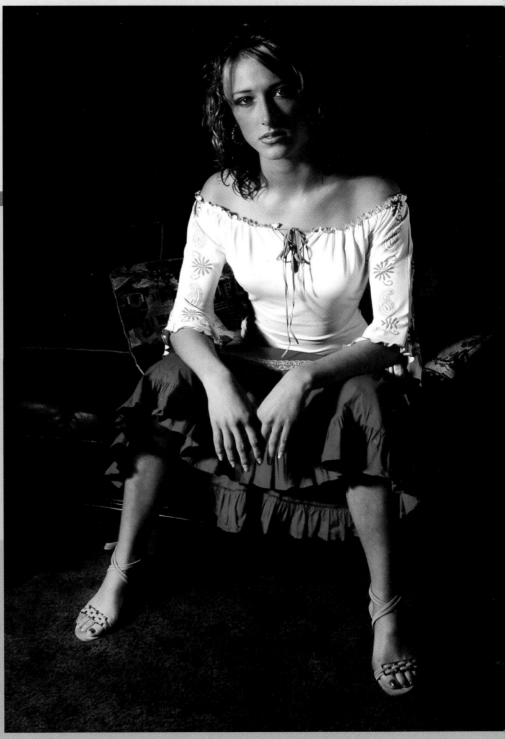

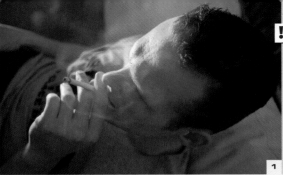

! Underexposing a photo with a view to brightening it later will show up any noise in the image, but if you are intending to create an atmospheric piece, this shouldn't deter you.

! Fuji has a new range of digital cameras with the designation SR. These use a new CCD process to capture double the dynamic range of other digital cameras, providing much more detail in shadows, midtones and highlights.

1

dramatic shadows

Control of light and shadow is the hallmark of studio portrait photography, whether that studio is a large custom-built one; a converted bedroom with white-painted walls; or simply your lounge. When you have the time to compose a shot and can control the available light in the scene then you can create much more idea-specific and precise images. Creating dramatic shadows can be tricky with the current crop of digital cameras because of the limited dynamic range of CCDs and CMOS chips. If you concentrate on shadow detail then it is usually at the expense of highlights. Fortunately, photo-editing at a later stage can help you fully realise your ideas.

shoot

London-based photographer Helen Jones was doing a shoot with model Charlie Kane, as he needed some new publicity shots. When the studio shoot was finished, Charlie lit up a cigarette to relax. Helen spotted the photographic potential of his pose, turned round one of her 500w halogen lights to light both him and the smoke, and started firing off shots with her Canon high-performance digital SLR, using a 28–200mm zoom lens. The advantage that digital SLRs have over smaller compact and non-interchangeable lens digitals is that there is much less depth of field at wide angles – a very useful facility in portraiture.

brightness/contrast

1/ The original photo was good, but the perspective was awkward and the shot needed to be more atmospheric.

2/ The contrast of the shot was increased via the Brightness/Contrast controls before being desaturated.

enhance

The picture was rotated, then cropped into to concentrate on what made the image work best – the smoke wafting around the subject's face. The contrast was increased via the Brightness/Contrast function [2]; this also added to the shadow areas. The image was then desaturated.

! When trying to create an atmospheric shot with plenty of shadow detail, it is better to underexpose the photo. Simply dial in a narrower aperture if using studio flash, or use negative exposure compensation if not. The lighter areas can then be brightened using photo-editing software to stretch the tonal range, but keeping the vital shadow areas.

enjoy

Charlie was just as pleased with this photo as he was with the portraits he had commissioned Helen to do, and he requested a print of this shot as well. Helen kept the digital original for her portfolio.

> rotate
> crop
> brightness/contrast
> desaturate

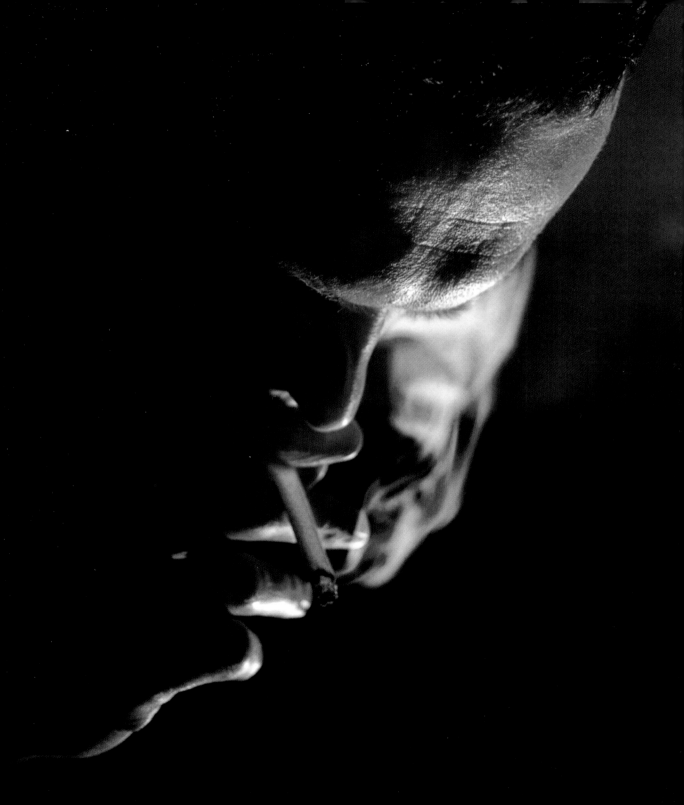

4 on location

Exploiting the rich possibilities of interior and exterior locations will lend extra drama to your portraits.

This portrait of writer and poet Edy Poppy was shot just before sunset on a dullish day in the autumn at Dungeness, on the southeastern coast of England. Gry used a diffused camera-mounted flash on a medium format camera, with an exposure of f/5.6-8 at 1/250 sec on a monopod.

The full 6 x 8 format of the camera was used on an 80mm lens. The image was then extended in Photoshop by stitching on another, similar shot with a slightly different angle, to make the format wider. Dungeness is a flat landscape, with nothing to break up the experience of 180 degrees of sky.

Originally the shot had a warm tone, with the low sun subtly brushing the landscape in the background, and Edy's face warmed up by the flash. But Gry's experience of the shot, and the day it was taken, was much cooler. She therefore cooled down the colours by partly desaturating the image and using blending modes selectively in combination with layer masks.

Dungeness by Gry Garness

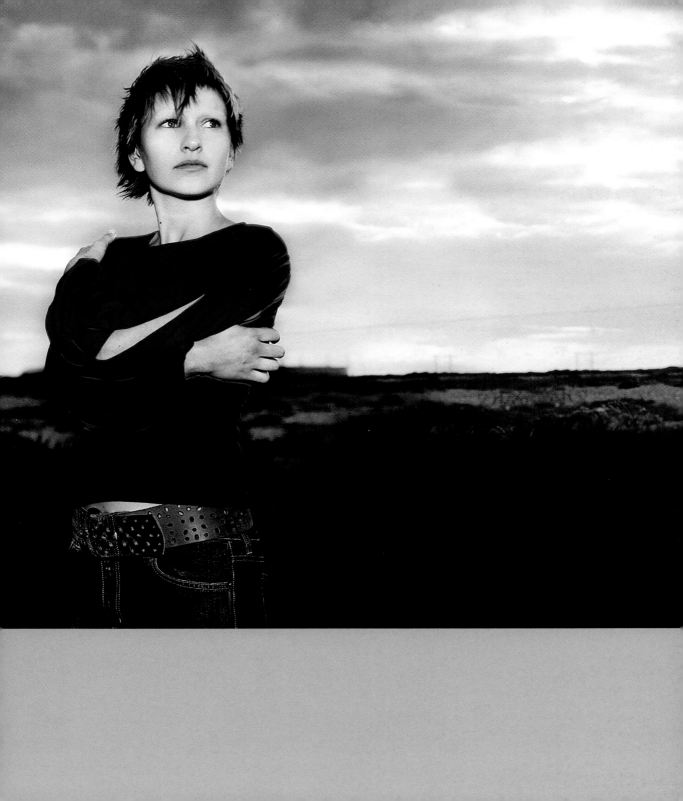

1

> 'I like portraits that give away a bit of personality, not just glossy, dead expressions.'

windowlit interiors

Photography is all about using light to create effects. Where sunlight streaks through blinds or windows, that light and shadow can be used to create stunning portraits. There are a few pitfalls to be aware of, however. When the sun is shining brightly, it can often lead to exposure problems that are not detected at the time. One solution is to place nets or a gauze-like material over the window so that the light becomes more diffuse. Another problem with bright light is that it can be difficult to use a wide aperture, which you might want to do to throw the background out of focus. Unless the camera has a very fast shutter speed, you will have to use a narrower aperture than desirable. Neutral Density filters can help, as they reduce the amount of light coming into the camera, but you may also need to use photo-editing software to obtain exactly the effect you want.

shoot

Trine Sirnes of Fredrikstad, Norway, shot this picture, which she calls 'The Beast Within II', using her Nikon consumer digital camera. She explains, 'The photo was one of several, thus the "II", that I took of me and my boyfriend in front of the window shades with afternoon sunlight shining through. The title came from the striking expression caused by the light, darkness and shadow. I like portraits that give away a bit of personality, not just glossy, dead expressions. These photos made me think of natural instincts and what we carry inside, good or bad: The Beast Within.'

2 variations

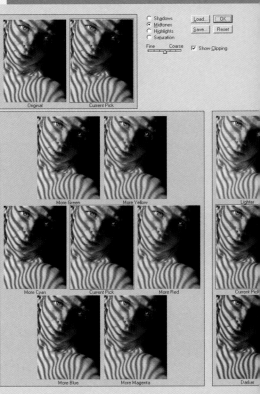

> crop
> clone tool
> feather
> new layer
> saturation
> selective colour
> variations
> saturation
> unsharp mask
> print

enhance

The original photo [1] had too much arm and torso visible so was cropped into the desired shape. Then the contrast was increased to make the stripes stand out more. The Clone tool was used to remove tiny flaws in the skin or areas where the sun had burned it out too much.

The irises were selected and a feathering of approximately 5 pixels was applied. A copy of this was pasted to a new layer. The iris was cleaned up to remove any

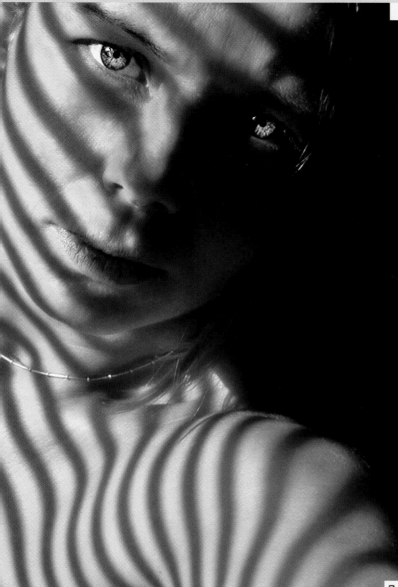

Trine mostly prints her photos for her own or her family's enjoyment. She has a picture in a travelling exhibition (www.dpinternationale.com), although not this one. Size is often a problem when preparing pictures for the web. You have limits of how big it can be in kilobytes and also in pixels, and often this can decrease the quality of the photo. Trine mostly posts at 640 x 480 resolution and, depending on the site it is intended for, a file size of between 100 and 350k. On some photos she uses a filter to give parts of the image a small amount of soft focus, then uses the Unsharp Mask filter on the parts that she wants sharp, such as the foreground or the model. This makes the photo look sharp, and avoids artefacts caused by the low resolution.

! When shooting in bright sunlight, watch out for the sun burning out skin detail in the resulting image.

! Digital cameras are sensitive to movement, especially with low light or long exposures, so it is often best to use a tripod.

bleeding of the colour outside it. The iris layer then had the saturation increased to improve the definition and create a more startling effect.

The colours were tweaked a little by using Selective Colour, and Variations [2] was used to give the image a toning effect [3]. The saturation was then altered to give the photo the correct tone. Finally, Unsharp Mask was used to put a little bite back into the photo, as digital camera pictures tend to be soft.

1/ The original image.

2/ Trying out Variations.

3/ The final version.

4/ Another shot from the session was given a similar dramatic treatment.

This photo was part of a series shot in a restaurant that had appealing old wooden floors and brightly painted walls. The light was variable because of clouds, but when the sun did come out it shone directly through the large windows. There were problems shooting the model in direct sunlight, because of the extreme contrast and the difficulty she had in avoiding squinting. Keeping the model out of direct light but using reflectors to bounce the light back onto her was the solution.

using interiors

The main attraction of shooting on location is that the setting for the shoot will have far more character than a studio-built set. If you don't have a large home studio, a location shoot is your best opportunity to photograph people in large, airy spaces. Obtaining permission for shooting in locations depends on where it is and who owns it. Some owners will be amenable; others won't. Many, particularly for indoor locations, ask for a location fee. A few hours in a local restaurant, between meal shifts, should be quite affordable for the average photographer; for anything more stately, the fees will be steeper. One alternative, if the location is a commercial enterprise, is to offer the owner a series of prints from the shoot for display.

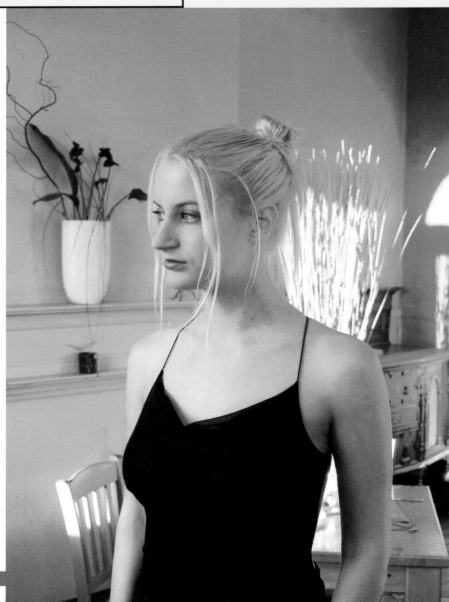

> increased contrast
> increased saturation
> magazine repro

A stack of rushes was placed behind the model in a position to catch the light. The photo was shot in Aperture Priority mode on an Olympus digital SLR at f/5.6 to keep the background out of sharp focus. Ideally, a wider aperture would have been better, but the resulting shutter speed of f/5.6 was right up to the maximum that the camera could manage. The use of a Neutral Density filter would have reduced the light coming into the camera and allowed the use of a wider aperture, but one wasn't to hand at the time.

enhance

Olympus digital SLR cameras tend to produce very flat contrast and neutral colours. Therefore the Curves control [1] in Photoshop was used to increase the contrast and the Hue/Saturation control [2] used to increase the overall saturation so that the image matched the vibrancy of the actual scene.

1 curves

2 saturation

! **Always visit a location at the time when the shoot is planned to take place, before the day in question. This allows you to judge important considerations such as crowds, security and where the natural light is going to be.**

1/ Increasing contrast.

2/ Increasing saturation.

enjoy

The final image was used to illustrate a magazine feature and was printed at A4, even though the printing resolution at that size was around 220dpi. Ideally you would want to print at 300dpi, but this requires a digital camera resolution that only the top-end models can offer. The minimum resolution that you can print at, even using an ink jet printer, and still get a satisfactory result, is 150dpi.

1

! Always have enough memory and batteries with you when shooting. It is very frustrating to see a once-in-a-lifetime shot only to lose it because your memory card is full, or the camera's batteries are dead.

outdoor locations

Using outdoor locations often means that you can practise candid photography and capture spontaneous and natural shots where the subject is unaware of being photographed. Normally, you will need a telephoto lens or a 6x zoom or more on a digital camera to obtain close-ups in these circumstances. Compact digital cameras make this much easier as they are small and discreet, and you can use them without holding the camera up to your eye.

There is a downside to candid photography on outdoor locations, in that the general public may be paranoid about having their picture taken. In these media- and celebrity-obsessed times, anyone aware of being snapped in the street may react with hostility, or demand payment for being photographed. There is also a very serious issue concerning the photography of children. While you may want to capture the youthful joy of childhood, you are advised to work with either your own, or friends' children, rather than those of strangers.

shoot

Trine Sirnes was on a hike with her boyfriend Knut Fredrik and his two sons to one of the islands on the archipelago outside Fredrikstad, Norway, where she lives. They were having a bonfire and, as it was autumn, there were lots of dead leaves on the ground. Trine had her Nikon small compact digital with a 3x optical zoom with her. She was photographing elements of nature when she spotted Knut with a faraway look on his face, and quickly took this shot.

2 flip > desaturate **3** clone tool

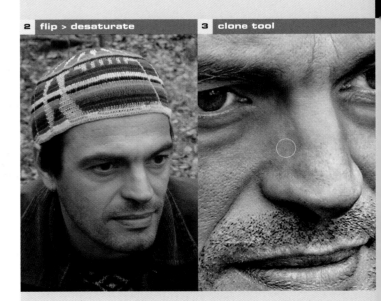

> orientation flip

> desaturate

> crop

> clone

> dodge and burn

> unsharp mask

> save for web

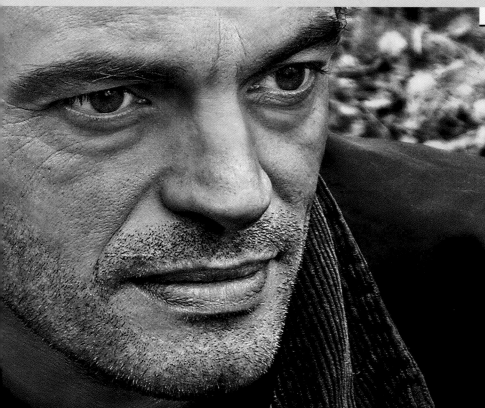

Trine makes prints for her friends, her family and herself, and hopes some day to sell them as well. When preparing photos for web use, you often need to reduce the photo's file size to be able to post it on websites. Trine usually downsizes photos to 640 x 480, and, depending on whether the website allows borders or not, puts a 100-pixel black border around the image. She uses the Save For Web function to get the file size down to around 100k, which is the requirement on many websites.

enhance

1/ The original image.

2/ The image was flipped horizontally and desaturated.

3/ The Clone tool was used after cropping to remove minor skin blemishes.

The original photo [1] was flipped around the vertical axis to reverse the direction that Knut was looking in. The next step was to desaturate the photo [2] to turn it into black and white, but still using the RGB colour space.

The image was then cropped, to get a close-up of his face. Then some adjustments with the Clone tool [3] were used to remove small flaws in the face, and then the Dodging and Burning tools were used to make the light more even. The highlights were removed and the eye area was made brighter. Finally, the Unsharp Mask filter was used on selected areas. It was used with high settings to bring out the texture and contrast in places, and with low settings on others to slightly sharpen the area.

! Back up your work: burn CDs of all your photos, and make second copies of all of them. You can't be too careful: you don't have negatives, PCs crash and CDs can easily be damaged.

1

urban life

Composition is everything in this photo. The subject lounges, at ease, while the city towers in the background. The low angles in the foreground contrast well with the verticals in the background and the toning work combines to show someone taking a brief respite from the urban rat-race. That person is Yann Keesing, who took this self-portrait with a Sony prosumer digital camera with a wide-angle lens adapter plus a Tiffen ND0.6 Grad filter. The photograph was shot using the timed shutter function.

Yann explains, 'I have been living in New York for about ten years now, and I'm soon going back to Europe. My life has been pretty hectic lately between work and the move preparation so it's hard to get "chill" moments. I wanted to shoot a self-portrait that would convey this message – a moment of tranquillity under high pressure – thus the dramatic toning contrasting with the tranquil pose.'

Urban locations offer a wealth of opportunities for portrait photographers. You can portray the contrast between the vitality of humanity and the grey world that we inhabit, or take a more reportage approach, chronicling the downtrodden and the dispossessed. On a practical note, you need to be careful when working in urban locations in case your equipment attracts unwanted attention from thieves.

If light levels are low, then wide apertures are necessary to avoid camera shake, and, if taking pictures of people, using fill-in flash will lift them out of their sombre surroundings. A gritty, monochrome feel is often very effective, so select high ISO ratings for the deliberate introduction of noise into the images, and turn them into mono on the computer afterwards.

! Don't be afraid to experiment: once you have the tools, post-processing does not cost you anything.

2 contrast mask

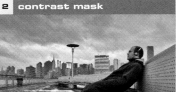

3 eraser tool **4** hue/saturation

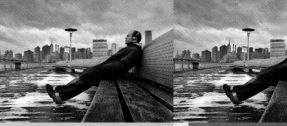

5 desaturation

6 eraser tool

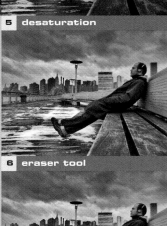

> duplicate layer
> desaturate
> invert and overlay mode
> gaussian blur
> eraser
> hue/saturation adjustment layer
> duplicate layer
> desaturate
> invert and overlay mode
> gaussian blur
> eraser

1/ Original image.
2/ The first contrast mask layer.
3/ Working with the Eraser tool.
4/ Adjusting Hue and Saturation.
5/ The image was desaturated to black and white.
6/ The Eraser tool was applied again for finishing touches.

First a contrast masking layer was created [2]: the original layer was duplicated and the top layer desaturated. It was then inverted and the blending mode set as Overlay. Gaussian Blur with a radius of 90 was applied.

The Eraser was used to delete some parts of the contrast masking layer where the effect was undesirable [3]. This included the face, parts of the bench on the left, the bench highlight area

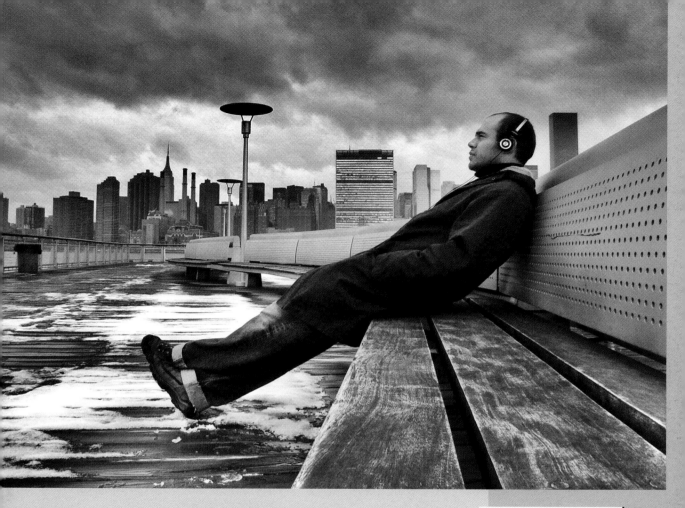

behind Yann's back, and the bench back between Yann and the lamppost.

A Hue/Saturation adjustment layer was created on top of the layer stack to tone it [4]. The Colorise box was ticked and values of Hue = 30, Saturation = 20 and Lightness = 0 applied.

A second contrast masking layer was created. The original image was duplicated and put on the top of the stack. It was desaturated to black and white [5], inverted,

and Overlay set as the blending mode as before. This time Gaussian Blur was applied with a radius of 250.

The Eraser tool was used to delete some parts of the second contrast masking layer where its effects weren't required [6]. These included the face (which became darker), Yann's coat (which became too light), and some snow areas (where the detail burnt out). The image was then saved.

! Always work on an uncompressed version (TIFF, Photoshop), as you won't lose any quality when saving. It's very important – never work on a JPEG!

enjoy

Yann made prints of this image for himself and friends using an ink jet printer. By using TIFF files throughout, the quality was maximised when it came to producing the ink jet print. At 300dpi the image measured 201mm x 148mm.

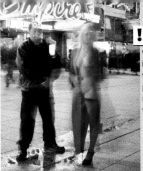

enhance

Even though this was shot at f/2 on an Olympus digital SLR camera, there is plenty of depth of field so that the background could become an integral part of the scene. At f/2 on a film camera, the background would have been completely out of focus.

Parts of the model were moving during the exposure and so are

Shooting nudes on location comes with both advantages and pitfalls. The positive aspects of shooting with a real, as opposed to studio, background and props – whether you are using a cityscape, old manor house, woodland dell or hotel room – will often outweigh the negatives. It may not be practical or desirable to shoot in your own house and you may not have the funds for a dedicated studio. In this case, shooting on location is a positive boon. For interior shots, you usually need to pay to hire a location. Using outdoor locations negates the cost, but means that you have the public to contend with, depending on where you decide to shoot. However, such situations can spark your imagination and creativity, and that in itself is worth pursuing.

shoot

This picture was shot for a magazine article about nudes across London. The concept was one of unexpected juxtapositions: a naked woman set against the evening crowds in the neon-lit streets of London's bustling Leicester Square. The man posed as a bodyguard or security guard, mimicking the security people outside the nightclub behind. With a tripod set up, a focus point was set. There was no point in trying to get the autofocus to work here; the idea was to do a long exposure where the model remained static, but the people in the background moved. Flash was discounted because it would probably pick up the passers-by, as well as attracting unwanted attention. A sequence of photos was subsequently shot, and the one where the model remained still was used in the feature.

1 hue/saturation

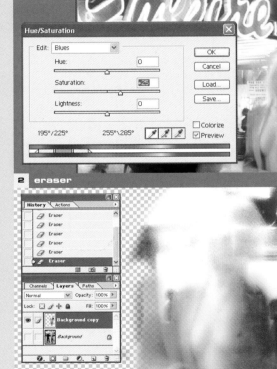

2 eraser

1/ Hue and Saturation was increased to enhance the neon-lit effect of the image.

2/ The Eraser was used to remove the Diffuse Glow effect apart from on the model, giving her an ethereal quality.

! If shooting nudes in public, have a minder in tow to keep intrusive spectators at bay.

> selective saturation

> crop

> clone and burn

> duplicate layer

> diffuse glow

> eraser

> interpolation

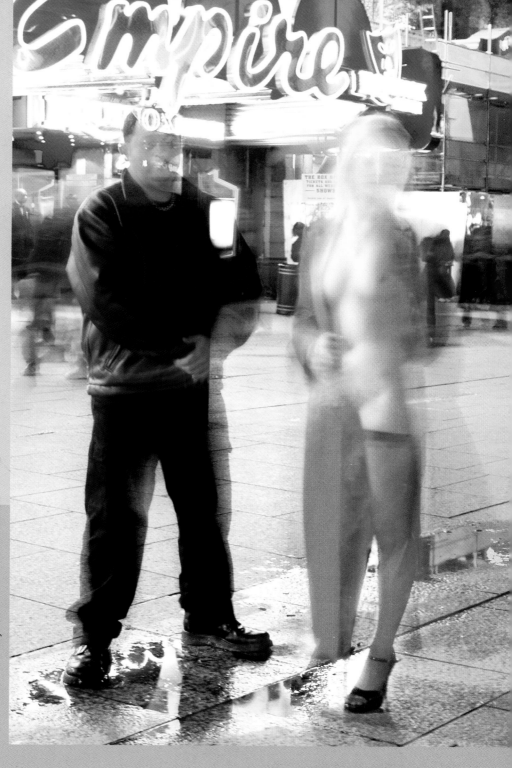

completely blurred. To add to the neon effect, the saturation was selectively increased [1].

The picture was cropped to centre the figures, including the ghostly aspect of the model's cape. A separate layer was also created and a Diffuse Glow applied. This was then deleted from all the background areas and left on the model herself [2]. This helped enhance the picture's ethereal quality, which had been the deciding factor in selecting this picture from others in the set.

enjoy

This shot, with some cropping and only a 5Mp starting image, needed to be interpolated up to 3000 x 2000 resolution in order to make it large enough for full-size, commercial use in this book. It was converted from RGB to CMYK, which has a smaller colour gamut and can sometimes kill an image, although fortunately that proved not to be the case here.

! When using flash, put the camera on Aperture Priority mode and dial in a high aperture such as f/11 or f/16. The camera will put out enough light to illuminate the subject, but the narrow aperture will make the background pleasingly dark.

! If the background scenery is interesting and you can convince your subject to stand still, use a wide aperture, an ISO of 100 and a tripod. You could also try the shot with slow-sync/second curtain flash to light the subject but also record the background.

1

night shots

Taking portraits at night is an art form in itself. You are largely prevented from using long exposures and tripods because you want the people in the photo to be in reasonably sharp focus – unless you are intent on creating an artistic effect. This means that you can either use flash, or try to use the available light. At night, the available light is artificial. This means you get different kinds of colour casts from it, which can make for interesting photos. However, the light needs to be strong enough to hand-hold the camera, and, if the subject is moving, it needs to be stronger still.

You can just about get away with hand-holding a camera at 1/15 sec, on a wide-angle setting, if the subject is standing still. If they are moving, you'll need 1/60. The trouble is that, at the regular ISO 100 rating, the artificial light would need to be a bright spotlight to get that kind of shutter speed, even with the aperture wide open. Enter the digital ISO, and the ability to increase this to 400, 800 and, in some cases, 1600 on affordable digital SLRs. Each time you increase the ISO, you double the shutter speed available, but the downside is that the digital noise increases. Some cameras are noisier than others, but most ISO 800 shots on semi-pro cameras will show a great deal of coloured noise. The alternative to all this is to use flash, but built-in flash flattens the picture. If possible, use a flash attachment, select fill-in flash, or reduce the power of the flash, to achieve a more natural look.

> crop
> layer copy and blur
> multiply mode
> dodge
> clone
> quick mask
> colour adjustment
> unsharp mask
> interpolation

shoot

Helen Jones was at the BAFTA awards in London, having been commissioned to photograph the stars as they arrived at the ceremony. Hollywood actress Halle Berry was photographed outside the Grosvenor House clutching her award. This kind of photography is a jostling bear-pit event, where you must fight to get a clear shot of the celebrity. Arty camera functions have no place here – it's a case of sticking it on auto and hoping for a decent shot. Fortunately, Helen was equipped with a Canon high-performance digital SLR with a 28–200mm lens – a 10Mp digital SLR with a super-fast shooting capability.

1/ The original image needed some drastic adjustments.

2/ The layers were blurred.

3/ Important areas of the image were sharpened.

2 **blurred layer**

3 **unsharp mask**

enjoy

After such severe cropping, the resolution of this picture was so low that it wasn't usable for commercial printing. As such, it needed to be interpolated quite a lot to make it suitable for printing at a larger size for this book.

Normally this degree of interpolation would not look good, with artefacts and possible jagged edges appearing, but with a subtle application of Gaussian Blur, a convincing result was obtained.

enhance

As the photo was shot at a grab-it-and-see angle [1], there was plenty of distracting detail. The first job therefore was to crop right into the picture. This was only possible because of the high resolution of the picture files. Anything smaller would have been unusable. Then a layer was copied and blurred to obscure the noise in the photo [2]. The blend mode was changed to Multiply to enhance the colours.

The eyes were brightened with the Dodge tool and some stray gleams of flash were removed with the Clone tool. Then, a Quick Mask was applied and used to hide the eyes. The colour balance was adjusted across the unmasked areas, adding yellow and some green to the photo. A little Unsharp Mask [3] was applied to sharpen key details. The layers were then flattened and the image saved.

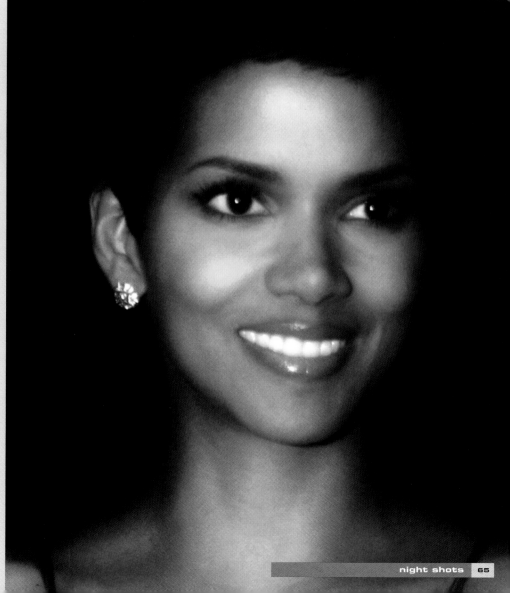

! If light levels are low, increase the **ISO** rating to the maximum. It doesn't matter about the noise because, in these circumstances, photos are all about spontaneity and interaction.

! If you are intending to do much street photography, it is vital to obtain appropriate insurance cover against your equipment being damaged or stolen.

crowd shots

Working on location often means that the photographer interacts directly with his or her environment. This style of photography is about spontaneity and immediacy: you can forget about careful composition, deliberate selection of depth of field and carrying a tripod. The lively interaction between subject and photographer is captured in this image by **Paul Rains**. If you don't have time to set the camera up for a particular effect, it should either be in **Program** mode so that it can take care of the exposure automatically, or in **Aperture Priority** mode, with the widest aperture dialled in to give you the maximum shooting speed.

shoot

Paul Rains took this photograph while on a trip to northern Togo in West Africa, in an area where white people were quite a novelty. It was taken during a recess break at a local school, when the children all swarmed out around Paul. Although they shared no common language, children and photographer interacted well. As soon as Paul showed them the pictures on the LCD, the children immediately began to pose for the camera. They became very enthusiastic and were happy to pose for pictures, which is how this shot got its title ('Enthusiasm').

enhance

Paul used a Canon PowerShot with a facility for setting the white balance, or colour temperature. Unfortunately, in this case the temperature was on the wrong setting for the conditions. The image was first converted from JPEG in the camera to TIFF to ensure that the quality was not degraded. The photo was then desaturated and the contrast adjusted through use of the Curves control [1] to increase the tonal range and make it more punchy.

> conversion to TIFF
> curves
> crop
> interpolation
> print

1 curves

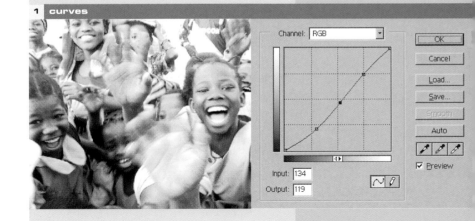

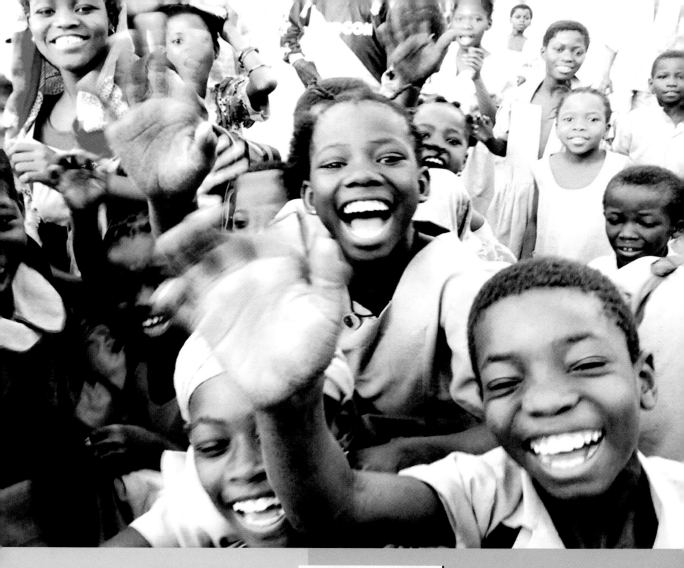

! This is shoot-from-the-
hip photography, so
fire off as many photos
as you can. You will be
lucky to set up
particular shots.

! Use the LCD to give
instant feedback to your
subject – it can encourage
them to be more natural
when posing for further
images.

enjoy

All of Paul's photography to date
has been for his own enjoyment.
With this photo being destined for
use in this book, it needed to have
the native file format of JPEG to
be changed to TIFF, and some
interpolation used to make it
larger than the original 1600 x
1200 resolution when printed at
300dpi.

1/ The Curves control
was used to adjust the
contrast and give the
image more impact.

5 weddings

When you are capturing a couple's special day, there is no need for traditional stilted poses: the modern style of wedding portraiture is far more innovative, informal and spontaneous.

This shot was taken with a Bronica Etrsi 6.45 format camera at Culzean Castle in Ayrshire, Scotland. To enhance the image, Gordon placed a new sky into the background and then flattened the layers. He then used the Gradient tool, set to Foreground to Transparent, to darken the sky area. Using the Colour Balance tool, he put a dark sepia colour over all the image and then used Curves to give the final picture an ethereal look. He also used the Lasso tool to select the bride's veil and applied the Motion Blur filter to give a little movement to the veil.

Guardian Angel by Gordon McGowan

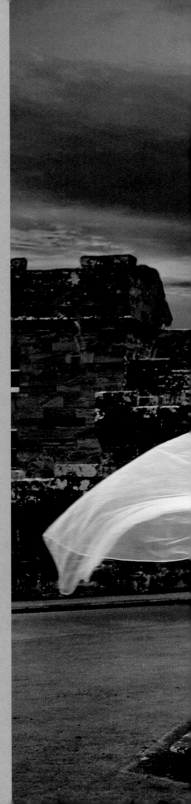

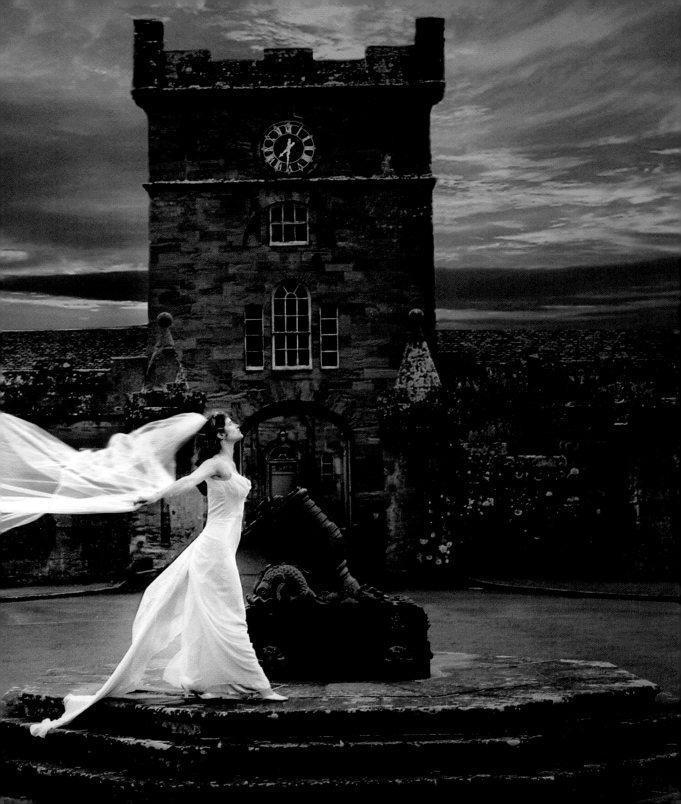

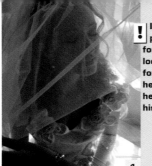

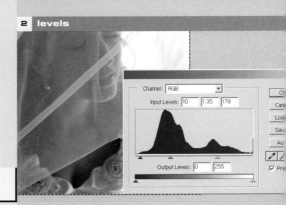

> In the hustle and bustle of the pre-service preparations, look for emotional shots – if anyone looks weepy, photograph them. Go for detail shots: the bride having her hair done; being helped into her dress; the groom adjusting his tie.

the preparations

Weddings give you ample photographic opportunities: you have access to a wide variety of people, wearing beautiful clothes, with lots of human drama and emotion to capture. With church weddings you also have a great location to work with.

Modern wedding portraiture offers the chance to capture far more interesting images than the traditional set-piece shots for the wedding album. Many couples are now often more interested in a personal or reportage style of photography, focusing on spontaneous and relaxed moments.

shoot

Andrew Maidanik took this shot in the bride's house during preparations for her wedding in Toronto, Canada. Andrew, a professional photographer, considers shooting the bride's preparations to be one of the highlights of the day. This evocative image was captured as the bride was passing a window, the light from which caught her veil. The picture was taken using the ISO 400 on a Nikon news and sport digital SLR with a 20–35mm zoom at f/2.8 to let in as much light as possible while minimising depth of field. The shot was taken with a low contrast setting in the camera.

enhance

First of all the image [1] was cropped to get rid of the hand at the bottom. This made the picture into almost a perfect square.

Then the levels were corrected [2], since the image was too dark and of low contrast, and the shot was converted to greyscale. The Image Mode was then changed back to RGB for sepia toning.

The process was completed by split sepia toning using the Colour Balance feature [3], by adding red and yellow to the shadows and midtones. The image was resampled at 300dpi for printing and saved.

1/ This image was taken as the bride was finishing her preparations.

2/ The levels were corrected to improve contrast.

3/ A split sepia toning effect was added to create a nostalgic mood.

> CCDs are much less forgiving than print film so the possibility of over- or underexposing your shot is much greater. Treat digital like the narrow latitude of slide film. Keep your camera contrast settings to low or normal; this will help you make all further enhancements.

> crop
> levels
> sepia toning
> resample
> save and print

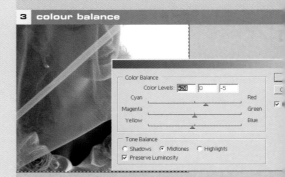

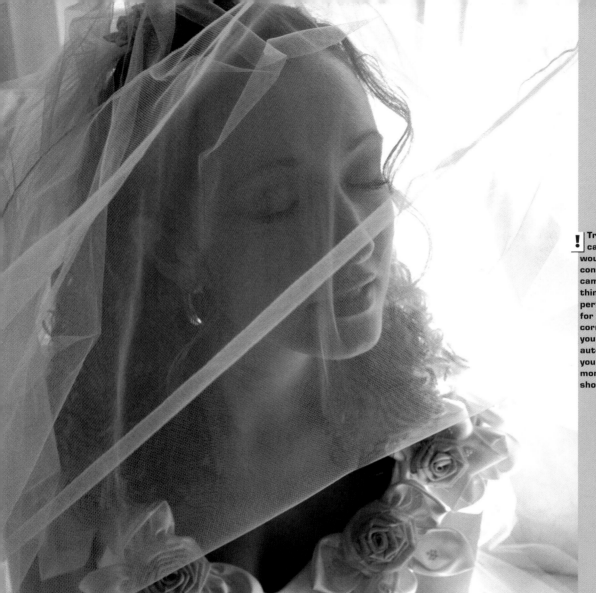

! Treat your digital camera as you would a conventional camera: do not think that it will perform the magic for you, or will correct any of your mistakes automatically, and you will obtain more successful shots.

! There is no difference between shooting digitally and conventionally in terms of the process of the light projection onto the light-sensitive image-capturing media, be it a **CCD**, **CMOS** or film. The principles of the process of image transfer to the back of the digital camera apply in just the same way as on the day that photography was invented.

enjoy

Almost all of Andrew's prints are made for his clients (whether for weddings, portraiture or products) and also for his own exhibitions. For the web, he uses Photoshop to create a 72dpi image, sharpening it to the required degree and then saving it in JPEG format using the Save For Web feature.

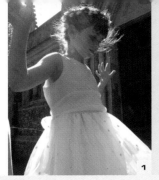

1

This image was taken by Helen Jones, a professional wedding photographer, at her brother's wedding. It was taken using a modest Nikon consumer digital camera while the formal photos were being shot just outside the church. Helen always works with a second photographer at weddings; someone else takes the formal shots, allowing her to capture the relaxed and spontaneous moments. This type of informal photography is favoured by many couples these days, but it is important to also capture group shots for the parents, who are quite often paying for the wedding. Helen always provides two photographers when commissioned for a wedding, to make sure that both styles are provided for.

candid moments

Candid or reportage-style photography, more than any other form of portraiture, relies on what the great French photographer Henri Cartier-Bresson called 'the decisive moment' – that point in time where the pose, action and environment encapsulate the entire circumstances of the shot. Look for that moment during regular wedding shots to add a distinctive and poignant memory to the wedding album.

enhance

Helen was compiling a black-and-white album as a gift, and she particularly liked the warmth in the original picture [1]. Initially, the AutoColour tool was used to correct the colours and contrast. To add warmth, the image was converted to greyscale and then changed to a duotone [2]. You cannot change the mode directly from RGB to duotone; it has to have the colour information discarded first. A mixture of black and yellow inks was used to create more warmth in the image.

The Healing Brush and the Clone tool [3] were used to remove an unwanted thread and a white mark down the left-hand side of the girl's dress. The duotone colours were then tweaked until they looked just right, and the contrast and brightness were adjusted as well.

3 clone tool

2 custom colours | **duotone options**

Book: PANTONE® solid uncoated		
PANTONE 456 U		
PANTONE 457 U		
PANTONE 458 U	L: 89	
PANTONE 459 U	a: -4	
PANTONE 460 U	b: 32	
PANTONE 461 U		

Type a color name to select it in the color list.

Type: Duotone

Ink 1: Black

Ink 2: PANTONE DS 3-5 C

Ink 3:

Ink 4:

Overprint Colors...

OK
Cancel
Picker

OK
Cancel
Load...
Save...
☑ Preview

enjoy

This image was printed for Helen's brother and his wife. It has also been used by two magazines to illustrate articles on weddings and wedding photography. Helen is currently working in conjunction with the Conran Group to provide wedding photography and this picture appears in her portfolio.

1/ The original image.

2/ The shot was converted to a duotone.

3/ Cloning was used to tidy up small flaws in the picture.

> autocolour
> greyscale
> duotone
> healing brush
> clone
> tweak
> print

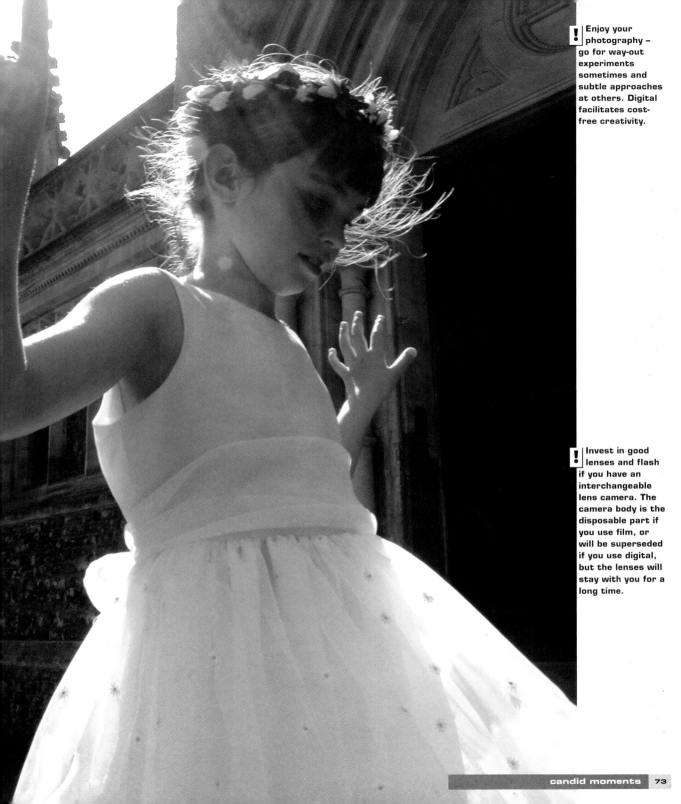

! Enjoy your photography – go for way-out experiments sometimes and subtle approaches at others. Digital facilitates cost-free creativity.

! Invest in good lenses and flash if you have an interchangeable lens camera. The camera body is the disposable part if you use film, or will be superseded if you use digital, but the lenses will stay with you for a long time.

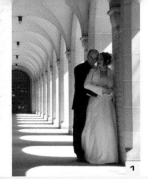

the bride and groom

As well as the fashion in wedding photography for reportage, for close-ups, and for individual moments on the big day, the bride and groom will always expect a classical shot of themselves, with no distractions, for their album. Putting on the ring, signing the register and cutting the cake all make for 'memorable moment' shots, but consider setting up a special shot too: after all, the couple will have gone to great lengths to look this good, and their union should be recorded in as stylish and memorable a fashion as possible.

shoot

This shot was taken by Andrew Maidanik in Toronto, Canada using a professional Nikon news and sport digital SLR with a Nikkor 28–70mm f/2.8 ED zoom lens. Away from the distraction of relatives, the couple relaxed and posed in a classical environment, making for a highlight shot in the wedding album later. With lots of white present in traditional wedding dresses, it is all too easy to lose the highlights, so it is advisable to shoot a little under the metered exposure; this can then be corrected in Photoshop later.

enhance

As the original image was a little flat, the Levels were first enhanced and the Blue and Red channels were subtracted [2]. The RGB channel levels were then enhanced. Then the image was cropped, unnecessary details such as lights on the ceiling were removed by using the Clone tool [3] and, finally, the shadows of the colonnade were darkened by using the Burn tool [4].

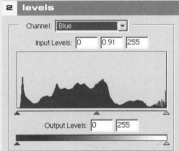

2 **levels**

Channel: Blue
Input Levels: 0 0.91 255
Output Levels: 0 255

3 **clone tool**

4 **burn tool**

1/ The original image.
2/ Adjusting Levels.
3/ The Clone tool was used to remove unnecessary details.
4/ The Burn tool was used to darken the shadows for extra impact.

enjoy

Andrew makes prints for himself, his personal exhibitions and for commercial purposes. This print was done commercially as a job for the people getting married.

> levels
> channel subtraction
> RGB enhancement
> crop
> clone
> burn
> print

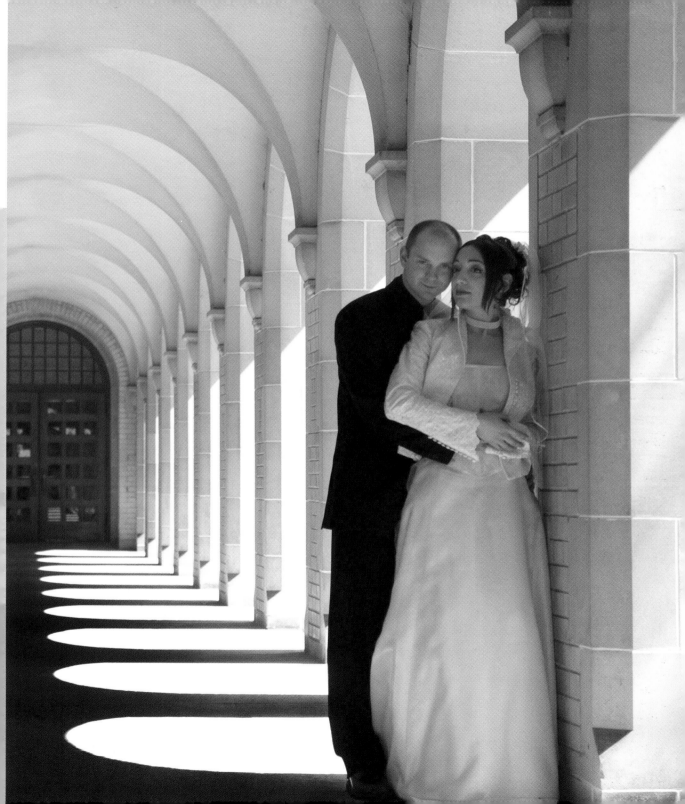

6 nudes

The classic nude is an art form in itself, but that shouldn't hold the digital portrait photographer back from trying this challenging and rewarding discipline.

The aim of this photo was to create a classic monochrome nude shot. Duncan used two light sources to create light and shadow across the model, who was asked to arch her body. The light on the right-hand side was the main light; this was aimed past the model and pointed to provide edge illumination and to create the shadow effect on the legs. The secondary light was set at half the power of the main light and aimed in front of the model to light the flooring and the surface of the model. This combination produced areas of bright light and shadow around the model, who herself was largely in shadow. The shot was taken in colour on an Olympus digital SLR, and was then desaturated to mono. The Levels were adjusted and more contrast put in, and the scuff marks on the floor that had shown up under the bright lighting were removed using a combination of the Clone and Blur tools.

Nude by Duncan Evans

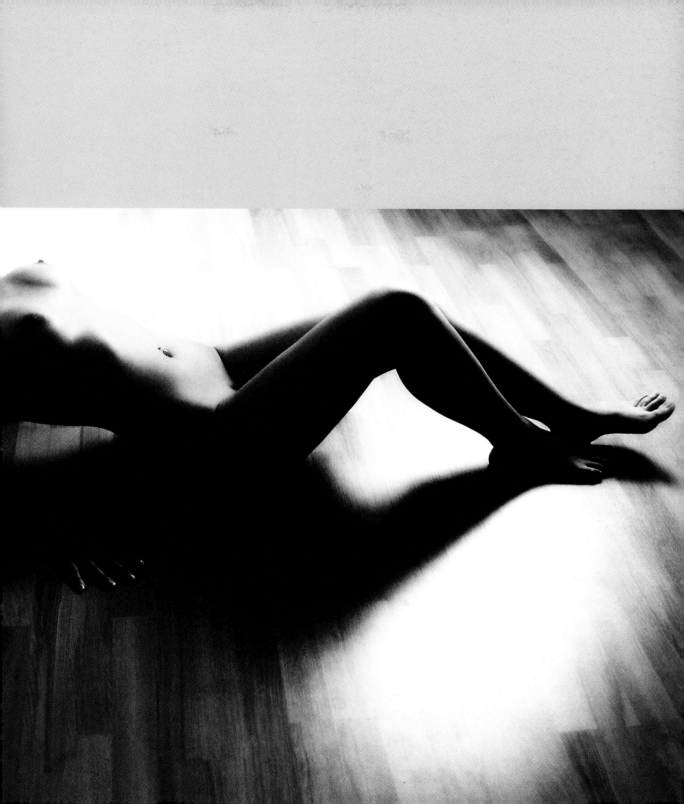

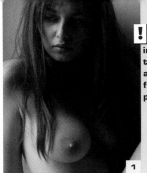

form and figure

The nude has always been a popular subject for artists. With the advent of photography, the artistic depiction of the nude has been just as popular and offers a rewarding proposition for the digital portraitist. It is important to differentiate between classic nudes and the glamour end of the market, although, as in all genres, there can be some crossover. The classic nude concerns itself with lighting, form, figure, posture and expression. In some regards this is the purest form of portraiture: the subject is baring their soul to the camera, and there is nowhere to hide. These are the themes that the classic nude photographer should explore.

shoot

Konrad (Jacek Jedrzejczak) of Warsaw, Poland, shot this image using only natural light. He was using an Olympus digital SLR, shooting with the shutter wide open to give the maximum aperture. This lets in the most amount of light and gives the fastest shutter speed without increasing the ISO rating. Doing that increases the digital noise in a picture, which might not be desirable. In subdued, natural light you need to watch the shutter speed because if it falls below 1/15 sec, there is every chance of camera shake ruining the photo. Konrad pushed these conventions to the limit. He had to use ISO 160 just to get a shutter speed of 1/8 sec, then wedged himself and the camera in a corner to keep it still. Usually, if the light level was that low, you would have to use a tripod. The other advantage of using a wide aperture is that it gives the least depth of field and throws the background out of focus. This is often desirable.

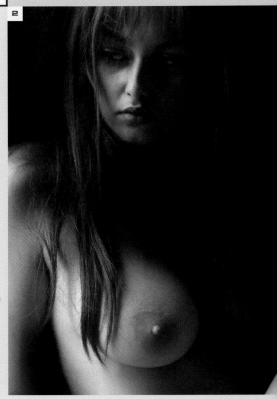

> retouch

> mask

> curves

> 3D filter effects

> sepia

> paintbrush

> brightness

> unsharp mask

> print

1/ The original image.

2/ The shot was enhanced with the addition of a sepia effect.

enhance

After converting the image to monochrome, Konrad retouched some of the elements of the face and body of the model. A hand-painted Mask layer was applied to different areas of the face. Then the remaining parts of the image were given the impression of shadow areas by applying tonal curves, contrast and gamma adjustments [2]. 3D filter effects were then applied to the face to give it a more curved feel. A sepia filter and tonal adjustments were then applied.

To balance the brightness of the photo, the Mask tool was used to mask parts of the hair in the right-hand side of the image. The brightness of those areas was then tweaked. To complete the photo, the Unsharp Mask filter was applied to give it a more defined edge.

enjoy

Konrad often makes prints to enter photographic competitions in magazines. In 2002 he won a bronze medal in Poland's Photography Championship and a silver medal in Argentina. He produces prints that are sold to private buyers. For web use they are reduced in resolution to about 700 x 500 pixels and about 50–100Kb file size in JPEG format.

 Finding nude models is easier than it used to be, largely because of the internet. There are numerous websites where models advertise their services, giving sample pictures, rates and locations.

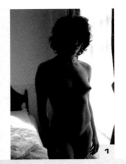

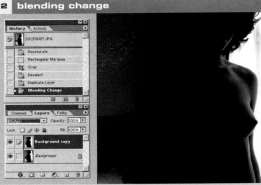

! When using natural light, check your shutter speeds – if it falls below 1/15 sec, you may need to use a tripod or increase your ISO rating.

light and shadow

Using light to full effect is critical in most branches of photography, but when portraying the nude it can make all the difference when trying to create an evocative study of the human form. Whether the light is used in the studio through careful positioning of flash units, or on location with available light from windows, being able to control where it falls, and where shadows are created, will make an image much more interesting. When photographing a nude subject, the idea is to use light to highlight parts of the body and to cast shadows across others, either obscuring, hiding, or adding mystery to those darkened areas. Using light and shadows on nudes is all about imagination.

shoot

Shot on location in Dublin, Ireland, the colour original of this photo was intended for a magazine supplement. It was part of a sequence of photos showing the model rising from a position of repose, shot only with the available light coming through the window. A Fuji digital SLR was used. This has a low ISO rating of 160, which made the f/2.8 zoom lens slightly more responsive than it would otherwise have been. It also has a very large internal buffer and can store photos on large-capacity IBM Microdrives. The ability to shoot continually was very important to the flow of the process. There was plenty of light near the window, so the camera could be used handheld without any danger of camera shake, but as the model moved away and into the room, the available light fell and the ISO was increased to 400. This made the images quite noisy, and consequently only one or two pictures shot at this rating were used in the feature.

enhance

The first step in changing the image was to desaturate it. It was then cropped to get a tighter frame. To make the image darker, a duplicate layer was created and the Blend mode set to Multiply [2]. This created a much darker image, but left the face and figure too dark as well.

Therefore, the next step was to use the Eraser tool, at 30% opacity initially, to remove the figure from the top layer. Once the edges were removed, the opacity was increased and the middle of the figure completely removed from the top layer [3].

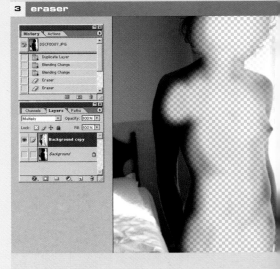

> desaturate

> crop

> duplicate layer

> blend mode

> eraser

> burn tool

> resample

> alternative image

enjoy

This version of the image was
resampled to 3000 x 2000
resolution so it could be printed
at A3 and entered for a
competition. Also, because I liked
the look of it, a second image
was created by cropping to the
top half and adding a red-sepia
tone [4].

One of the benefits of digital
imaging is the ability to create
different photos from the same
original.

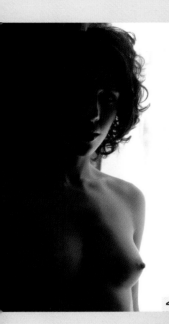

4

1/ The original image
was shot in colour as
part of a series for
publication.

2/ A moodier shot was
obtained by darkening
the image.

3/ The Eraser was
used to restore the
original brightness of
the subject.

4/ An alternative
image was produced
with a different crop
and a red-sepia tone.

This left just the original
underneath, which showed
through at the intended
brightness, while all around the
image became darker. The layers
were flattened and the Burn tool
was used to darken everywhere
else around the main figure that
required it.

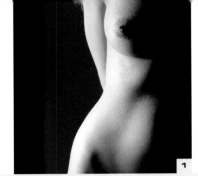

1

abstract nudes

Whereas one form of nude photography is dedicated to form and figure, another branch deals with the abstract expression of the human form – 'the body landscape'. Let your lens explore the curves, skin, muscle and bones of your subject. You can either shoot at very short range using macro functions to blow up specific areas so that they are represented in larger format and detail than usual, or shoot from further back, but zoom in and isolate areas where textures, shapes and lines are formed.

> crop

> levels

> rotate and crop

> airbrush

> RGB colour mode

> sepia toning

> save at 300dpi

> print

> save for web

shoot

Andrew Maidanik of Toronto, Canada, prefers to use black and white for his nude images. He tends to eschew the usual digital practice of shooting in colour and desaturating by switching the camera into black-and-white mode to start with. This shot was taken on a Nikon news and sport digital SLR at ISO 125, using an Elinchrome studio flash unit fitted with a barn door attachment to direct the light. The shot was taken as one of Andrew's personal lighting technique studies, which he carries out on a regular basis. He thinks that it is the best way to learn different light patterns. Just one degree change of the model or the light source can alter the entire scene.

2 levels

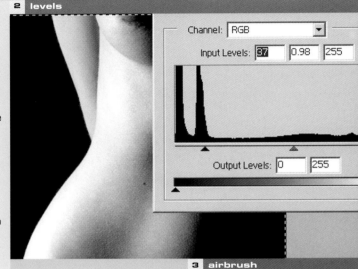

Channel: RGB
Input Levels: 37 0.98 255
Output Levels: 0 255

3 airbrush

Brush: 182 Mode: Normal Pressure:

enhance

All the necessary cropping was done to give the image the look of Andrew's original compositional line idea. The levels were enhanced [2]; some of the background was showing up because he hadn't been able to avoid lighting it up. The black levels were increased to the point where the grey background on the left started to disappear into blackness, and this in turn increased the contrast of the image.

1/ The original image.

2/ The levels of the image were enhanced to boost contrast.

3/ Parts of the image were airbrushed black for extra impact.

! When you start working with any digital file, and it is not in **TIFF** format, always convert it to **TIFF**. Every time you save any changes in **JPEG** format, and continue working on it later, you lose at least five per cent of the quality, even if you save in the lowest compression (highest quality). So if you save it five or more times, your print file may have a much worse quality than the original.

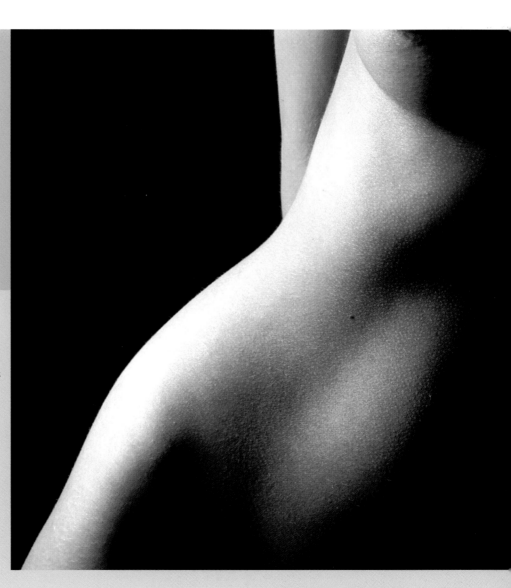

enjoy

Almost all of Andrew's prints are for clients and his own exhibitions. He has sold a few prints of this work to private collectors through personal exhibitions and the internet. For the web he uses Photoshop to create a 72dpi low-resolution image, sharpening it to the required degree and saving it in the JPEG format using the Save For Web feature.

The image was rotated 15 degrees clockwise and cropped again to get rid of the rest of the background, and the bottom right corner was painted black using the airbrush [3]. The Image Mode was then changed to RGB for further sepia toning.

The image was sepia toned using the Colour Balance feature, by adding red and a tiny amount of yellow to shadows, midtones and highlights. Finally, the image was saved as a 300dpi TIFF file for printing purposes.

7 fix it up

Don't despair when lighting problems, harsh sunlight, cluttered backgrounds and colour casts appear to ruin your pictures. Photo-editing software can correct all these things and salvage images that would otherwise have been deleted.

Helen had been commissioned by a photography magazine to cover the BAFTA awards as a test for the new Canon high-performance digital SLR. She took this shot of Daniel Day-Lewis, who had just won the Best Actor award, with a 28–200mm lens and Canon flash.

As the shot was taken ad hoc, Helen had no time to arrange a careful composition. The image was therefore cropped close into Daniel's face for impact. Unsharp Mask was applied to sharpen the shot before the image was desaturated. Finally, Helen made a copy from the background, applied a blur and made it into an overlay layer.

Daniel Day-Lewis
by Helen Jones

shoot

I was shooting interiors using studio flash. This would not usually be a problem as studio flash is balanced to work at the same temperature as daylight. However, the Olympus digital SLR I was using had previously been used on an interior shoot with artificial light and so was using a specific white balance setting rather than being on automatic. This resulted in a colour cast that was only really apparent when looking at the image on the computer after the shoot. Fortunately, Photoshop 7, Paint Shop Pro 8 and Elements 2 all have facilities for correcting such a situation.

colour casts

Digital cameras come with automatic white balance. This alters the colour temperature of the picture to match that of the scene. This is not infallible: the lower the actual light level, the less accurate it is. However, photo-editing software can be used to correct the white balance.

enhance

As there was no external light causing the colour cast, it was uniform with a yellow-orange tinge. Where separate light sources cause casts, areas need to be corrected individually. In this case, a general remedy was applicable. Image > Adjust > Variations was selected [2]. The trick is to apply colours opposite to that of the colour cast: in this case, blue and cyan were added.

A final tweaking was employed by using the Hue/Saturation control [3] and picking the remaining problem area – the

3 hue/saturation

background. It was selected first, and then the individual hue was adjusted to give the correct colour.

2 variations **4**

! **The Variations command in Photoshop and Elements allows for easy, but general, colour correction. If the cast is over all the image uniformly, this option provides a simple solution.**

1/ The original image had a colour cast due to the white balance being preset rather than the automatic setting.

2/ After a few adjustments, the final image was restored to its natural colour.

3/ Further tweaking was carried out via the Hue/Saturation option.

4/ The final, corrected, image.

5/ An alternative rescue treatment for photos affected by colour casts may be to convert the image to monochrome.

! The more severe the colour cast, the harder it is to rectify. You can easily shift small colour imbalances, but if the effect is severe then a correction in one area can detrimentally affect another. The answer is to try to mask each area prior to hue shifting and to repair each main colour separately.

! If a photo is beyond redemption and the colours cannot be corrected, then the last recourse is to turn the photo into black and white, perhaps adding some grain for extra mood.

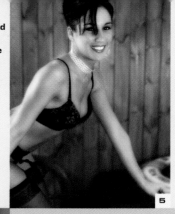

5

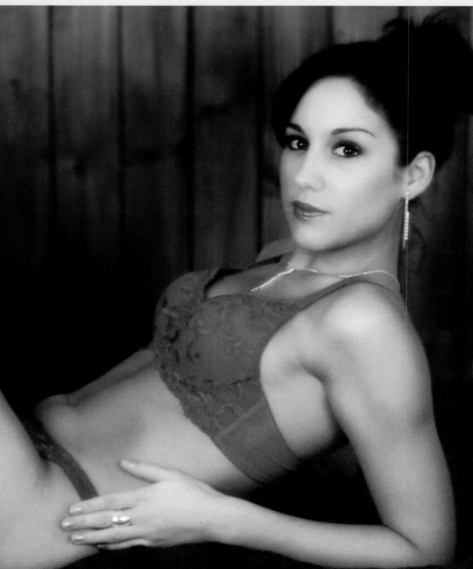

! Light has different colour temperatures at different times of the day and in different weather conditions. Colour daylight film is balanced at around 5500K or 5600K (degrees Kelvin) on a scale that incorporates candlelight at one end and harsh white skies at the other. What happens when the recording medium is set at a greatly different temperature from the actual conditions is known as a colour cast. Candlelight gives a reddish cast; tungsten a yellow light; fluorescent strip lighting a sickly green. Other light – usually natural – sources above the standard daylight temperature give shades of blue.

enjoy

Variations of this photo were used for a magazine feature on boudoir photography and subsequently printed at 300dpi for commercial reproduction. A smaller version was resampled to 480 x 320 for use on the web.

shoot

Whether you are shooting out of doors or in interiors, distracting backgrounds can create problems. The interior shot here was taken with an aperture of f/2 to blur as much of the background as possible. However, the camera was an Olympus digital SLR, which is a victim of its own sharp lens, and captures a riot of unwanted detail in the background. The exterior shot was shot at an open-air dance festival for general promotional use. It is often the case when shooting ad hoc on locations that you cannot control the background – you can simply capture the action and take remedial steps later.

distracting backgrounds

One common mistake is having a distracting background. Digital cameras can have as much as six times more depth of field than a film camera, and the sharply focused background competes with the subject for the viewers' attention. Fortunately, image-editing software can save the day.

! Use a wide aperture when shooting in rooms, unless you want the background to feature – digital cameras have much more depth of field than film cameras.

2 feathered eraser

enhance

A similar technique can be used to knock out the background in both interiors and exteriors. In both these shots, the first step was to make a duplicate layer and blur it using Gaussian Blur to lose all detail in the background. Then the subject was cut out through the blurred layer using a feathered eraser [2]. The next step was to adjust the colours in the background. In the interior shot, the background was desaturated; in the exterior, the colour balance of the top layer was adjusted to decrease the range of colour, with all the hues being moved towards blues and greens [3]. With the exterior, an alternative, lighter, background was also tried out [4]. The layers were flattened before saving.

1/ The original image, taken at a festival featuring dance displays. It was not possible to control the background.

2/ The feathered eraser blended the subject convincingly into the new, knocked-back background.

3/ The final image.

4/ An alternative lighter background was tried out.

5/ The original of this shot was taken in a Victorian house. The pots, vertical beams and flowers create a riot of distracting detail in the background.

6/ The final image, with the background desaturated and subdued to throw due emphasis onto the subject.

> duplicate layer
> gaussian blur
> eraser
> colour adjustment
> layer flattening
> save

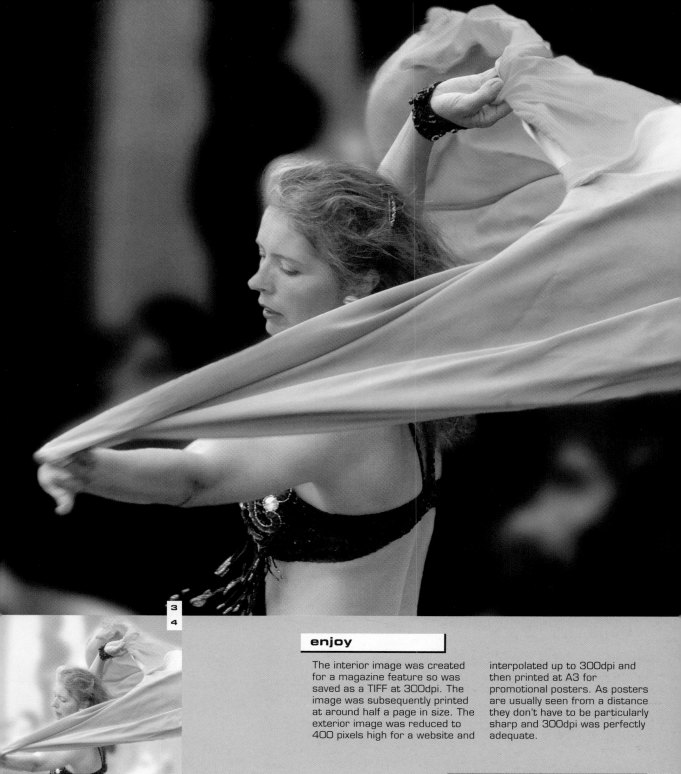

3
4

enjoy

The interior image was created for a magazine feature so was saved as a TIFF at 300dpi. The image was subsequently printed at around half a page in size. The exterior image was reduced to 400 pixels high for a website and interpolated up to 300dpi and then printed at A3 for promotional posters. As posters are usually seen from a distance they don't have to be particularly sharp and 300dpi was perfectly adequate.

back lighting

The original aim of this photo was to capture the sun shining through the model's hat and casting patterns on her face. Unfortunately, this aim went wrong on all counts. There wasn't any pattern showing in this photo, and the sea was much brighter than the model and so was overexposed. The ugly sea wall in the background and poor composition didn't help either. The exposure for the model was okay, however, because I used centre-weighted metering. I was expecting her to be a little bit dark so that the (missing) patterns would show clearly. Only photo-editing software could save this image.

enhance

Shooting with the sun behind a subject's back can be potentially disastrous. The default metering system will usually try to cope with the intense light and the subject will appear as a black shadow. You can position yourself so the sun is behind you, but you may then have the subject squinting into the sun. If you don't realise what you've done until you get home, it will be too late to address the problem with the flashgun or metering options, but photo-editing can still save the day.

Rather than trying to improve the sea area, the simplest solution was to crop the picture to get rid of it. This also improved the composition. To add atmosphere, a duplicate layer was created and three selections were made (you can hold down Shift to add to a selection). These selections were feathered by 50 pixels, and the Brightness control was used to make them look like sunbeams [2].

The selections were removed and then a feathered Eraser was used to remove the sunbeams from the foreground where the model was. The erasing of the beam around the edge of the hat was less extensive to give it the feel of flaring around and burning through. The face and body areas were completely cleaned up though. The layer blending mode [3] was changed to Screen to provide an extra glow, and then the layers were merged.

The image was turned into greyscale to remove the colour and then duotoned with a soft yellow colour to give it a light, summery feel [4]. Finally, Curves were used to brighten the midtones where the model was slightly dark and to increase the haziness of the sunlight areas.

> crop
> duplicate layer
> selections
> brightness control
> eraser
> blending mode
> greyscale
> duotone
> curves
> RGB print
> interpolation
> CMYK save

2 brightness/contrast

3 blend

4 colour

1/ Sometimes well-thought-out plans don't work, but, with the aid of photo-editing, a different image is waiting to be born.

2/ A sunbeam-type effect was created.

3/ The Screen blend mode was used to create extra glow in the image.

4/ Selecting a summery shade for the duotone.

5/ The final image.

6/ An alternative version of the same image but with a pastel-pink duotone and the midtones pulled up.

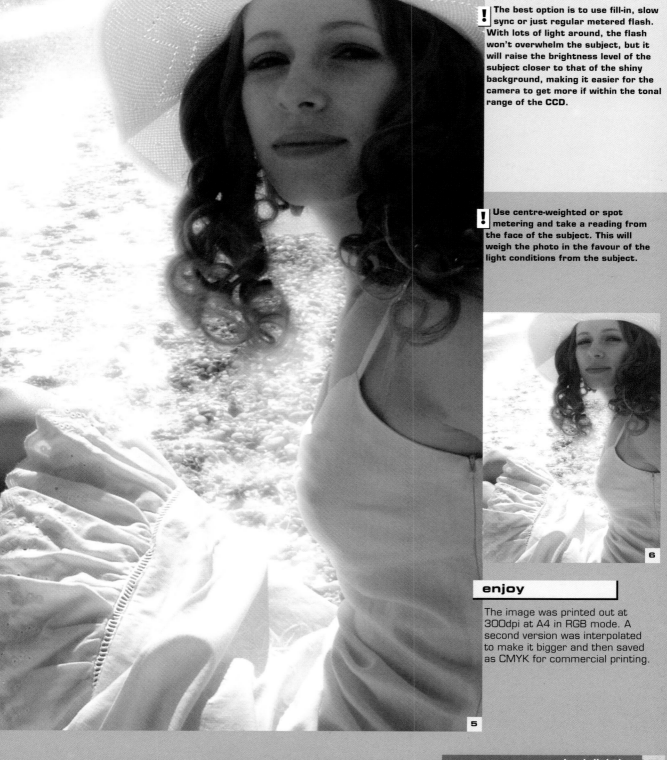

! The best option is to use fill-in, slow sync or just regular metered flash. With lots of light around, the flash won't overwhelm the subject, but it will raise the brightness level of the subject closer to that of the shiny background, making it easier for the camera to get more if within the tonal range of the **CCD**.

! Use centre-weighted or spot metering and take a reading from the face of the subject. This will weigh the photo in the favour of the light conditions from the subject.

enjoy

The image was printed out at 300dpi at A4 in RGB mode. A second version was interpolated to make it bigger and then saved as CMYK for commercial printing.

1

This shoot was taken on location in a restaurant. A strong afternoon sun was blazing through the windows, but was intermittently hidden by scudding clouds. One minute there was plenty of warm light, and the next it was fiercely bright. The intention with this shot was to try to get the sunlight to cast shadows across the model. She had enough problems looking towards the light, but the real problem arrived courtesy of the metering. The zone metering saw a predominance of shadows and midtones and exposed for

burn out

2

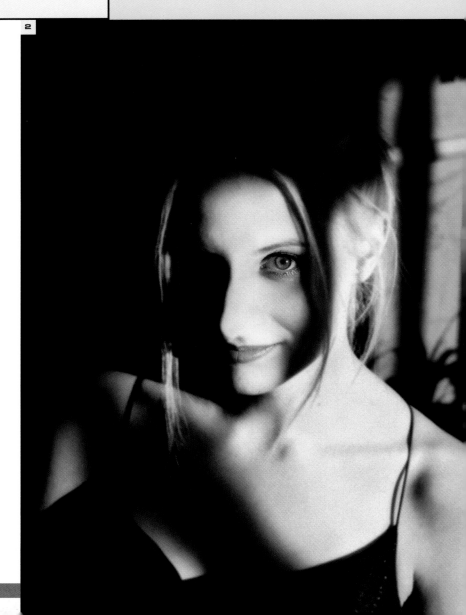

Many of the more expensive digital cameras have a tendency to underexpose photos, and this means that something from the picture will always be salvageable. This happens only with the higher-end cameras because (according to the manufacturers' reasoning) people using the pro or semi-pro kit might be taking the photo for money and won't be pleased if the shot is ruined. People with lower-end cameras or amateur digicams won't be so bothered.

Using software makes it possible to rescue underexposed photos. The more underexposed it is, the noisier the final image and the worse the quality, but if a photo is only a little undercooked it can still be saved. Overexposed images are not so salvageable. With these you lose detail – the highlights – and you simply can't get it back again. However, with photo editing, you can cheat.

> duplicate layer

> clone

> blend mode

> burn

> hue/saturation

> grain filter

> save

those. The result was that the highlights were burnt out. The way to shoot this kind of picture and not lose the highlights is to use centre-weighted metering and meter off the sunshine spots. There will be lots of dark shadows, but you will also obtain highlight detail and that's what you want.

! When shooting in bright sunlight, it is advisable to avoid having the subject look directly into the sun. Position them at an angle to avoid squinting.

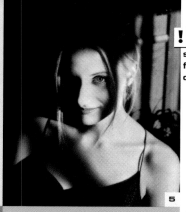

5

! If the sun is behind the subject, use fill-in flash to ensure a correct exposure.

3 blend mode

Darken | Opacity: 49%

Lock: | Fill: 100%

Background copy

Background

4 hue/saturation

Edit: Yellows

Hue: 21

Saturation: 0

Lightness: 0

OK
Cancel
Load...
Save...

40°/70° 100°\130°

☐ Colorize
☑ Preview

! To get a silhouetted figure against sunshine, use spot metering and meter off the bright, sunny areas, then recompose and shoot without releasing the fire button.

enhance

'Enhance' wasn't really the word for this operation; it was a salvage job. The model's shoulder, the top of her arm, and her forehead, nose and chin areas were all affected and lost texture. The trick was to put enough back in for the image to look okay. A duplicate layer was created and the Clone tool used at 15% opacity. The cloning area selected was not one where an exact match was to be found – that would be impossible – but rather where there was a light skin texture, and a fair amount of it. Skin was subsequently cloned into the affected areas, but at a very light opacity: the object was to put texture in, not to change the

brightness. Small areas such as the forehead were easy because the surrounding areas were simply extended until the burnt-out section was covered.

Once completed, the new areas looked slightly patchy in places. After some tidying up, the blend mode was changed to Darken [3], which added those corrected areas to the original image in a more seamless fashion. The Burn tool was used to bring out the texture even more, but this had a knock-on effect – the skin tones turned yellow in places. Hue/Saturation, using the colour picker to select the yellow tone, was used to shift the tone back to normal [4]. Finally, a light Grain filter was used just to add extra texture across the photo.

enjoy

While this photo was shot for a magazine feature, it was never used because of the burnt-out areas, and could easily have been deleted. However, because the pose and the shadows were so attractive, the image was kept on the hard drive, waiting for the day when it could be restored. That happened specifically for this book; the image had its print density sized to 300dpi and was changed to the CMYK colour model for printing.

1/ The original photo suffered from burnt-out detail in a number of areas thanks to the harsh sunlight flooding in through the restaurant window.

2/ The completed image with restored texture and added grain.

3/ The Darken blend mode was used to help blend in the corrected areas.

4/ The skin tones were corrected via the Hue/Saturation controls.

5/ An alternative worth considering, particularly if the skin tones suffer during the restoration process, is to turn the image into mono, and add some extra grain for a more moody effect.

8 radical changes

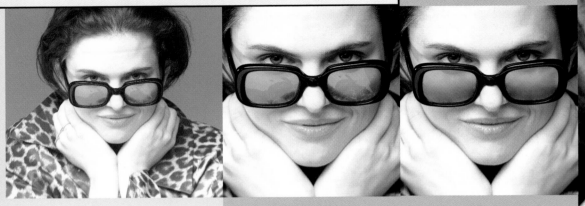

One of the great advantages of digital imaging is the ease with which a photo can be given a completely different look, so let your creativity loose.

Sophie by Helen Jones

This shot came about when Helen was commissioned by Simon Murray of Onspec Ontic to take pictures of sunglasses from his collection. Helen used actress Sophie Linfield as her model. She finds that actresses often make excellent models and Sophie's classically beautiful face was perfect for the commission.

The shot was taken with a Kodak digital SLR with a 200mm lens. The first stage was to crop the image. Helen then removed the hairband from Sophie's fingers using the Clone tool, and used the Healing Brush to remove a mark across her forehead caused by wearing a hat. Next, Helen worked on the reflections in the sunglasses using the Healing Brush. She then experimented with changing the colour of the glasses by selecting the lenses and using the Adjust Hue/ Saturation tool.

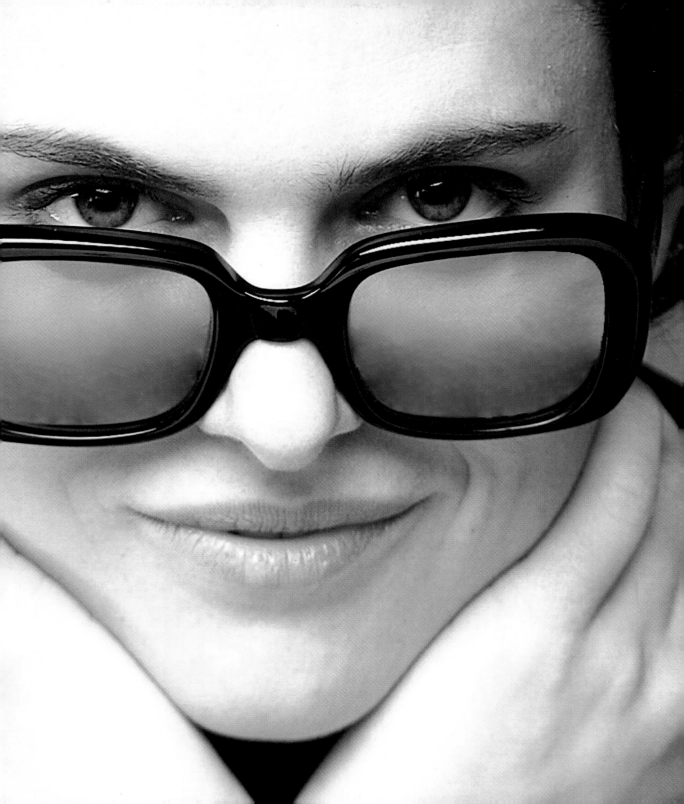

This photo was taken in a small studio. The idea was for the model to look vibrant and lively, and I overexposed the photo while retaining texture. The meter reading said f/11 and a selection of shots was taken at f/5.6 and f/8. This one was f/8; the rest of the high-key effect was created in image-editing software. One advantage of completing the rest of the image on the computer is that you have an original shot that can be manipulated in a number

1

high key

The purpose of the metering systems in cameras is to produce an exposure where the midpoint of tonal range equates to an 18% shade of grey. All film and digital CCDs have an exposure latitude, which is the range of shades from dark to light that they can capture. Levels of light reflecting from surfaces below this range come out as black on your picture, while high levels come out as white. The 18% grey shade corresponds to the middle of this range. However, there is a style of photography that eschews this traditional range, and instead concentrates on using shades only in the top half of the luminosity spectrum. This gives rise to very light, white and airy images, known as 'high key' photos. Portraits lend themselves particularly well to the high-key treatment.

The high-key effect can be created at the photo-editing stage, but by taking a regular photo and shifting the tones in this fashion you will lose the contrast, or, if you try to keep it in sync with the brightness, you will produce ugly colouring and the photo will become overdone. The trick is to deliberately overexpose the photo, while keeping in mind just what details will start to be lost. The more you overexpose, the more detail you will lose. On portraits it is imperative to retain the key facial features of eyes, eyebrows, nose, lips and hair. The skin tones can be brightened but retain all texture, or you can go completely over the top and burn right out. How far you go depends on the look you want – this is a creative and versatile style of photography.

> levels

> curves

> paintbrush in colour mode

> save at 300dpi

> diffuse glow

> alternative image

1/ The original photo was overexposed by one stop.

2/ The histogram of the original shot shows the tones concentrated in the top end of the spectrum.

3/ The Levels histogram was used to increase the white content of the image.

4/ The final image utilised some colour retouching of the lips and eyes for dramatic effect and to ensure that they stood out.

5/ This alternative version was created with the Diffuse Glow filter to white-out more of the image and give it a softer look.

The Levels histogram was manipulated by dragging the right-hand input slider towards the middle [3], thus increasing the white content while retaining the contrast. If you modify the output slider, the image can be made lighter but loses all contrast.

Curves were also used to tweak the image and to ensure that sufficient detail remained in the key areas. The Paintbrush in Colour mode was used to give the lips a frosty blue look [4]. An alternative version of the image was created using the Diffuse Glow filter for a softer look [5].

of ways – if it hasn't lost too much texture by greatly overexposing in the first place [2]. When shooting using natural light, use a metered exposure mode and then dial in +1 or more exposure compensation. The camera will subsequently make the image brighter. If using a studio flash system, then take the meter reading and, in manual mode, dial in a lower f-stop than the meter reading.

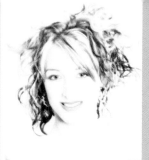

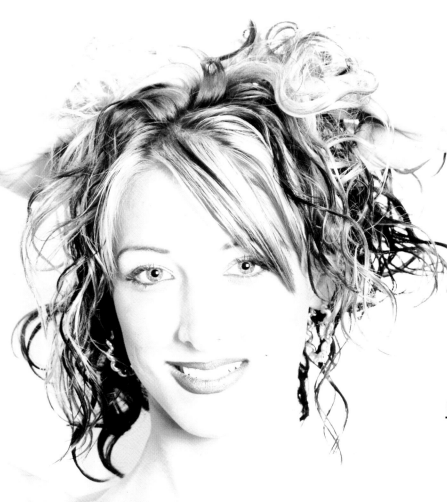

! If you want to obtain a light and airy look to an image, try to avoid losing texture and consider using the photo in mono or a light sepia, which can be very effective.

! If you want to create a radical burnt-out look, then colour can be very effective. Use plenty of eye and lip make-up and burn out the image so that just the key features remain.

! When editing a regular photo for a high-key look, use Levels and move the right side of the tonal range slider to around 210 or 75% to compress the range into the light end.

enjoy

A photo from the same series was used to illustrate a magazine article about fashion-style photography. The picture was shot as an uncompressed 5Mp TIFF for maximum quality and printed at 300dpi.

enhance

The background needed to be replaced, so the model had to be cut out first. She was selected accurately, but the hair was just cut around at this stage. The selection was feathered and copied to a new layer. Then the panels of wood textures were loaded – these

1/ The original picture was taken in colour, in a modern hotel room.

2/ The panelling effect was pasted into the background of the original image.

3/ The Transform tool corrected the perspective of the background.

4/ The Eraser was used to remove traces of the original backdrop.

5/ A triple spotlight effect was applied.

hand colouring

The photographer James Wedge became known in the 1970s for his risqué images of girls in Moulin Rouge-style outfits. He shot them in mono, printed them and then hand-painted the results. The process was very time-consuming and mistakes were not easily rectified. Digital imaging makes the process of hand colouring much easier, and doesn't carry the risks of ruining precious originals. Hand colouring works well with shots that have a period look, although the technique can be applied to any image.

> select
> copy to new layer
> load textures
> transform & perspective
> clone
> burn
> eraser on hair
> paintbrush/darken
> paintbrush/colour
> lighting effects
> 300dpi printing

shoot

This shot, taken with a Fuji digital SLR, was intended for a magazine feature on recreating the decadent and provocative music-hall look. One of the classic poses in this genre is that of a woman sitting on the edge of the stage with lights shining up from below. You don't need to have a set of stage lights to create this look as it can be simulated in photo-editing software. If you don't have access to a room with a stripped wooden floor, let alone a music hall setting, photo-editing can help you out here too. This image was taken in a modern hotel room, and the wooden panelling was added in later.

2 paste

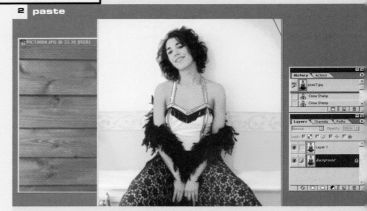

were simply digital photos of areas of panelling.

Firstly, the wood behind the model was selected and copied, then pasted into the main image [2]. The Transform option was used to scale the panelling to fit the area behind her [3]. This process was repeated for the other pieces of woodwork. The area of wooden seating was stretched using the Perspective Distortion tool to make it look smaller at the back than at the front.

All the pieces of wood in the layer palette were selected and merged. Where there were gaps between the textures, the Clone tool was used to fill them in. The Burn tool was used to

blend the corners realistically and to add a shadow behind the model on the panelling. To blend the hair in, the Eraser tool was used at 35% to remove the yellow halo [4]. The trick was to remove just enough for the background to show through so that no details of the hair were lost. Then the paintbrush was used with a brown colour and a Darken blend mode to cover up the remaining yellow.

The Burn tool was used to add a little depth where natural shadows would fall. The image was then flattened and desaturated to remove all colour. The paintbrush was selected, and various colours chosen to repaint the image. The blend mode was set to

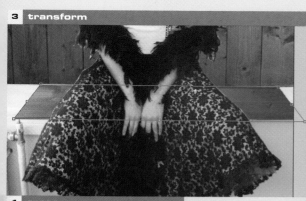

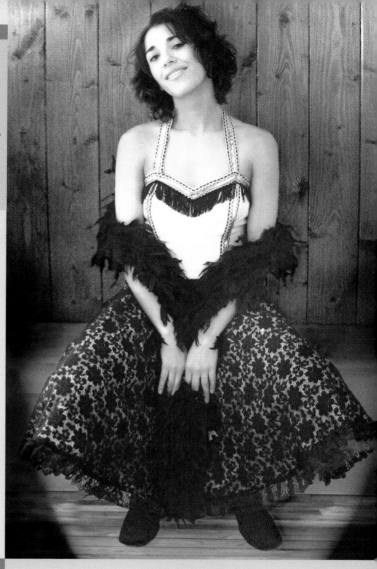

! You can use almost all photo-editing packages to do hand colouring provided that they have a Colour blending mode option for the Paintbrush.

Colour, which enables you to paint over the image without wiping out the luminosity. Finally, the stage lighting was added with the Filter > Render > Lighting option and a triple spotlight style [5]. This was positioned for effect and applied.

! When painting, use a solid brush near to the edges of areas of solid colour to avoid any unwanted colour-bleed into the next area.

Style:	Triple Spotlight	
Save...	Delete	

OK Cancel

Light type: Spotlight
☑ On
Intensity: Negative — 10 — Full
Focus: Narrow — 100 — Wide

Properties:
Gloss: Matte — 0 — Shiny
Material: Plastic — 69 — Metallic
Exposure: Under — 65 — Over
Ambience: Negative — 13 — Positive

Texture Channel: None
☑ White is high
Height: Flat — 50 — Mountainous

☑ Preview 🔆 🗑

enjoy

The full details of this process and all the intermediate steps were published, with the finished image printing at A4 at 300dpi. The Fuji camera used produced 6Mp images, but with a combination of a large canvas for the ensemble and a little interpolation, the final image was big enough for commercial reproduction at A4. The beauty of a project like this is that if it is saved at the monochrome stage, after all the editing, then an infinite number of coloured variations can be produced.

1/ The colour original of a photo from a series demonstrating 1930s' style lighting techniques.

2/ The image was converted to mono and cropped for extra impact.

3/ The layers were merged and blended before the final adjustments.

4/ The final image with the red tint strengthened.

changing faces

enhance

The image was desaturated and cropped to emphasise the face [2]. Then a light Grain filter was applied to add texture. A duplicate layer was created and the blend mode set to Multiply to bring out the texture.

These layers were merged together. A red-biased tone was added and then the layer

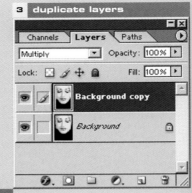

3 duplicate layers

shoot

One great difference between digital imaging and traditional chemical processes is the ability to experiment with no costs, no mess and no danger of ever altering the original. As well as simply improving or correcting a picture, photo-editing software allows you to create radically different photos from an original image.

This photo, taken with an Olympus 4Mp digital SLR, was originally intended as part of a series recreating classic Hollywood looks from the 1930s. The subject was shot with direct flash to generate the loop-lighting shadow effect on the face typical of the era. The pose is an interpretation of a 1934 shot by E. R. Richee of Sylvia Sidney. In that photo, Sylvia has dark hair and white fur wrapped under her chin. My model had blonde hair, so I used dark feathers for my shoot. Although it was shot in colour, I always intended to convert the image to mono. Later, in the process of writing this book, the expression of the model prompted thoughts of giving the photo a completely different look.

2 desaturate > crop

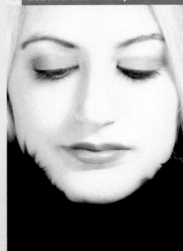

duplicated and blended again as before [3]. The Burn tool was used to define the right-hand side of the face. The Curves function increased the contrast in the darker areas and brightened the lighter ones. Finally, after merging the layers, the red tint was increased in strength.

enjoy

After creating this entirely new image, titled 'Dark Angel', I thought about entering it for a competition. For this it needed to be printed at A3, but I had used a 4Mp camera and had already cropped right into the image. The picture was increased in size during the processing, but to print at A3 would give a print density of only 150dpi – the minimum you should print at on ink jet printers. The image was subsequently resampled to 220dpi and printed out on a Canon A3 6-ink tank ink jet. For TIFF-format files, this caused the 7Mb original to jump to a whopping 17Mb. It was also downsized to 640 x 480 resolution to produce a version for my website.

> desaturate
> light grain
> multiply layers
> tone
> burn
> curves
> red tint

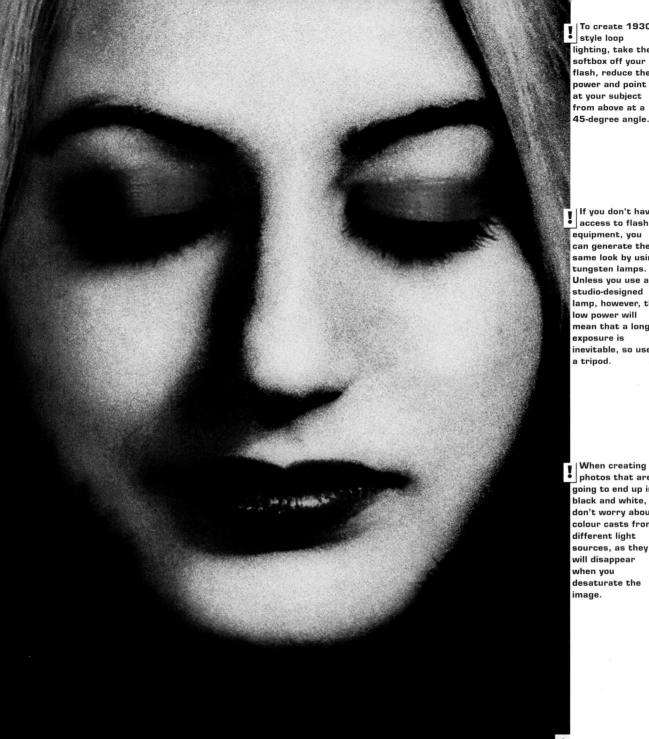

! To create 1930s' style loop lighting, take the softbox off your flash, reduce the power and point it at your subject from above at a 45-degree angle.

! If you don't have access to flash equipment, you can generate the same look by using tungsten lamps. Unless you use a studio-designed lamp, however, the low power will mean that a long exposure is inevitable, so use a tripod.

! When creating photos that are going to end up in black and white, don't worry about colour casts from different light sources, as they will disappear when you desaturate the image.

4

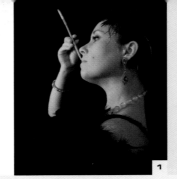

1

> **Lenses from the 1920s were not very good and never produced a sharp image. If recreating this kind of look, apply some Gaussian Blur to soften the image.**

adding shadows

All digital cameras have a certain range of exposures that they can manage in one shot. This is the exposure latitude. It is quite narrow, rather like slide or transparency film, but unlike print film, which has a much wider exposure latitude. For this reason, you may find that your digital images don't have quite the degree of chiaroscuro you might like. In addition, you might have to take a portrait when the lighting isn't ideal, or you might not have the lighting set-up required to achieve a sophisticated photo. In these cases, the answer is to add shadow detail at the photo-editing stage. People developing their own film have always had the option of burning detail into the final print, but with digital you can completely transform the look of an image by changing the areas of light and dark.

shoot

Using a Canon PowerShot digital camera in black-and-white mode, Shelley Sanders from Oklahoma, USA, set about creating a period-piece photo. She had a 1920s' flapper costume from a fancy dress party and wanted to photograph herself wearing it. Using just one floodlight, she was confident that, with some post-production on the computer, she could create a vintage feel to the image. To obtain this look, all you need is a black background and a light source. A tungsten lamp is ideal for this kind of work – the classic Hollywood portraits all used tungsten lamps – because you can direct it and see where the shadows are. Another advantage is that, with conversion to mono, there are no colour casts to worry about.

> colour balance
> airbrush
> curves adjustment
> diffuse glow
> gaussian blur
> interpolation
> print

2 **colour balance**

3 **curves**

4 **gaussian blur**

1/ The original photo was shot in mono mode using just one light source.

2/ A sepia effect was created via the Colour Balance option.

3/ The midtones were enhanced using Curves.

4/ Gaussian Blur was added for an atmospheric glow.

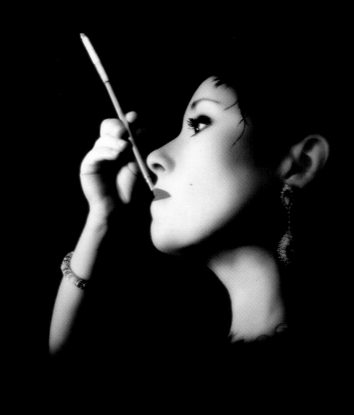

! The lenses from the 1930s were better, but the film stock was still susceptible to creating haloes and losing highlights. Being black and white it also recorded reds very strongly, so ensure when shooting in colour to increase the red component before desaturating.

enhance

The first step was to colour the photo with a sepia hue. To do this, Image > Adjustment > Colour Balance was selected and red and yellow were added to the midtones [2]. Adjustments can be made to create exactly the sepia look desired.

Next, some shadows were airbrushed into the picture, all the way up to the neck, giving the picture an oval shape. To fill in more shadows, the Curves adjustment was used to enhance the darkness of the midtones [3].

To create the kind of pale look characteristic of the era, the Diffuse Glow filter was used, but without any grain setting. The effect was applied with minimal settings to create the right look without losing highlights, which it can do with stronger settings. Gaussian Blur was then used to smooth the skin and help give the picture an almost ethereal, slightly fogged, appearance [4].

enjoy

This photo was created purely for Shelley's personal satisfaction, but it was interpolated to 3400 x 2400 pixels, which is sufficient to enable printing out at A3. Shelley also reduces images down in size for use on the web. Be aware that this will often remove things like grain and distinct texture, which may have to be reapplied for a web version.

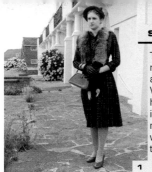

This shot was taken for a magazine feature on recreating aspects of the Second World War. This image related to the home front in Britain, and the image required was one representing the Blitz. As this was a tutorial feature, the cost of the shoot had to be something that the average reader could reasonably afford. My home town of Clacton-on-Sea in Essex is lacking in bombsites, but it does have a boarded-up and elegant hotel dating from around 1910, which provided the perfect backdrop. The model had the kind of put-upon look that was required

1

compositing

Compositing is the art of adding elements together in pictures to produce another image. The early years of digital photography were plagued by endless poor examples of compositing, with stuck-together animals and mismatched scenery, which many commentators dismissed as gimmicky and vulgar. People have been compositing images since the early days of photography. One famous example from the 19th century was the 'Cottingly Fairies', with which two young girls duped Sir Arthur Conan Doyle, author of the Sherlock Holmes stories. The photographs that the girls produced, featuring stuck-on paper fairies, might seem laughable today, but they caused a sensation at the time. With the advent of digital photography, compositing was reborn, giving people the tools to exercise their imagination.

enhance

The first task was to turn the photo into mono by desaturating it. After that, the Curves Function was used to boost the contrast. Then the background details to the left were removed by carefully creating a selection that covered that side of the image. When completed, the area was painted black [2].

The selection was removed and two new, overlapping ones created. These were the searchlights. After the first selection searchlight was created, the Shift key was held down so that the second could be added. A 10-pixel feather was then applied to give a little light leakage, and the inside of the selection was painted white. A duplicate layer was created and a lighting filter applied to it [3]. The new layer was then blended with the Multiply mode to darken the image.

! Most fancy-dress shops will have a 1940s' outfit of some sort that you can hire cheaply.

> desaturate
> curves
> selection and painting
> painting searchlights
> lighting filter
> variations
> add text
> save

2 paintbrush

3 lighting effects

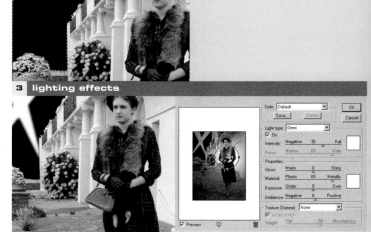

for this image, while the authentic 1940s' clothing, make-up and accessories were provided by an expert stylist. A series of shots was taken outside the hotel, with the model looking plaintive and distressed. The concept was of a woman grieving for her loved ones.

Variations were then applied to create a sepia tone. The final step was to select an appropriate font (20th Century Poster) and write the text out. A layer style for both lines of text was created separately so that each line could have a drop-shadow effect proportionate to the text [4]. Then the layers were flattened and the image saved.

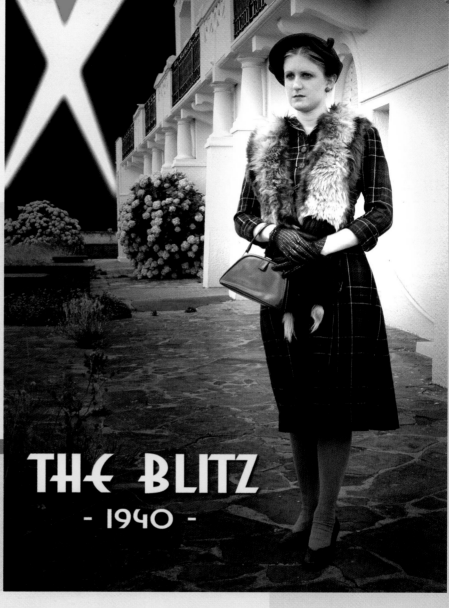

THE BLITZ
- 1940 -

4 drop shadow

1/ The original colour file complete with modern houses in the background.

2/ The unwanted background was painted out.

3/ A searchlight effect was added.

4/ A font appropriate to the era was chosen for the text.

! Using a stylist is not essential. Study photos from the time or popular films and style appropriately, with slicked-back hair for men and pale complexions and red lipstick for women.

! Shoot in colour and desaturate afterwards. You can then produce alternative versions that use weak, desaturated colours as well as mono and sepia effects.

enjoy

This image was printed in the magazine at 300dpi for commercial reproduction. The model also requested a copy for her website and this was produced at 640 x 480 resolution.

9 toning and ageing

With digital imaging you can distress, destroy, tone and age your photos without the laborious processes of the chemical darkroom.

Theo took a tangential approach to create this atmospheric and dreamlike image. He asked the model to close her eyes and tell him what perceptions she felt in her surroundings, such as the sounds she could hear or prickles on her skin. To try to reproduce this experience – what Theo calls a 'complete map of perception from a certain time' – he took various images, scanned them on a drumscanner and put them all into Photoshop and combined them in layers. These layers were flattened into one image and saved.

Sleep by Theo Berends

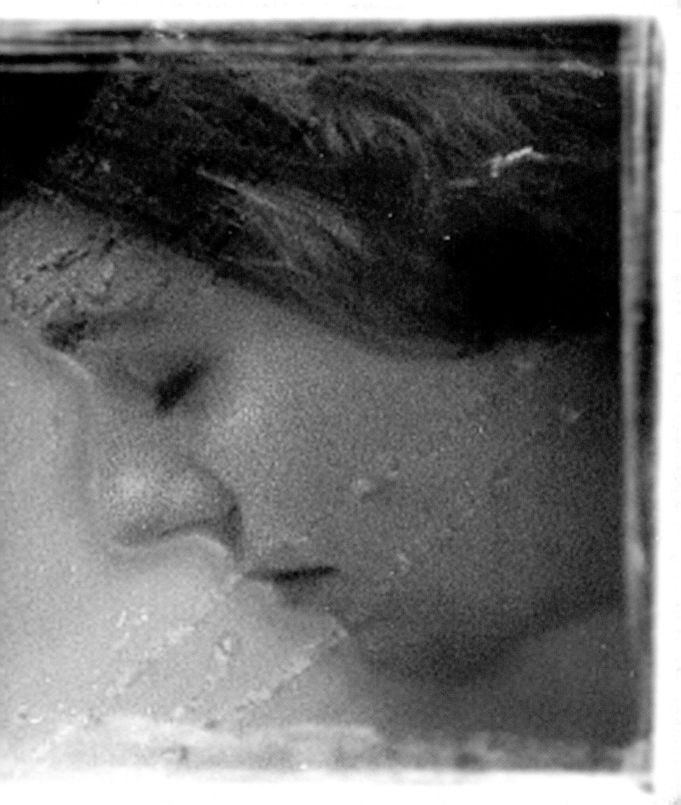

shoot

This image was taken on a spring morning on Clacton-on-Sea pier in Essex, UK. Being spring, there were few tourists about, so the owner of the shop behind wandered outside to observe the proceedings. In the original photo, his presence has little impact, but with substantial cropping, a very interesting image was created. It was a bright enough day to use f/2 or f/11 on the Olympus digital SLR I was using. If I had used a narrow aperture, then the man in the background would have been highly visible and a distinct part of the picture. I used a wide aperture, which means that he fades into the background but is still visible.

1

instant nostalgia

The tools available to the digital photographer to repair and restore old and worn photos can also be used to recreate the effect of that kind of damage on modern images in order to enhance their character. Sometimes the subject matter lends itself to such treatment because the ageing effect complements the content, as was the case here.

enhance

The original picture was fine, but it was changed to create a very different shot. First of all, a very tight crop was used to isolate the woman in the frame with the character in the background. The image was then desaturated [2].

A duplicate layer was created. This was treated with a Gaussian Blur to blur the background. Even with an aperture of f/2, the SLR I was using still resolved more detail than I wanted. The Eraser at 35% opacity was then used to erase the middle of the model and her face, leaving edges with a nice soft touch and the background out of focus [3].

Variations was used to add a basic sepia tint and then the contrast was adjusted using Curves to bring up the model and the patterns on her face from the hat. Finally, to make it look like a 1950s' print that

2 crop > desaturate

3 eraser

had been removed from a photo album, the picture was imported into Paint Shop Pro 7 and a photo border applied [4]. The opacity of this layer was reduced to 15% to give the sellotape effect.

> crop
> desaturate
> duplicate layer
> gaussian blur
> eraser
> variations
> curves
> paint shop pro 7
> photo border
> interpolation

4 photo border

1/ There was nothing wrong with the original colour photo, but it could be turned into something entirely different.

2/ The image was cropped and desaturated.

3/ The model and the background were softened using the Eraser.

4/ A photo border was applied to add a further nostalgic touch.

! A number of effects can be applied to make a picture look older and more characterful. The most obvious is to apply a sepia tone, but adding frames and borders; fading the image; adding damage and changing the colours to represent those of a different decade are some other ideas.

enjoy

After substantial cropping, the picture needed to be interpolated in order to get it up to the 300dpi at A4 resolution required for use in this book. Unlike landscapes, where such treatment is likely to ruin the picture, it is easier to get away with this in portraits, particularly ones where the picture is meant to be old or is soft. In such cases, the image can be interpolated and no remedial work is required afterwards.

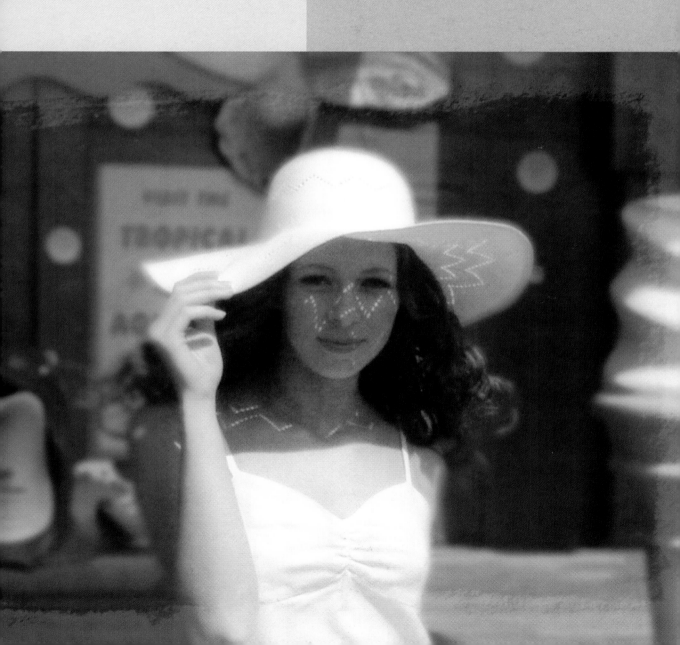

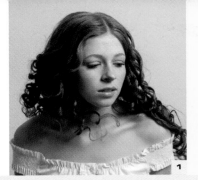

1

The original image [1] was shot in the studio with one flash and a softbox to the right and above the model. Jessops Portaflash series 3 equipment was used, which gives a maximum aperture of f/11. The camera was an Olympus digital SLR, which, co-incidentally, also had a maximum aperture of f/11. The model was asked to turn her head towards the light, but to look down, to give the impression of sadness, loss or mystery. A fan blew the model's hair around to give the image some life and movement.

sepia and grain

6

Grain is something that film users are familiar with; larger film grain gives faster responding films. In digital photography, the **ISO** rating applies to the level of light required to generate a pixel recording. The higher the rating, the less light it takes to register, but the less reliable and more subject to fluctuations the process becomes. This translates into noise, which is generally unpleasing in colour images because digital noise is multi-coloured. If the image is converted to black and white, the noise becomes more like film grain, albeit of one particular and well-defined size. Turning the photo into sepia colours can then transform it into an atmospheric reminder of yesteryear.

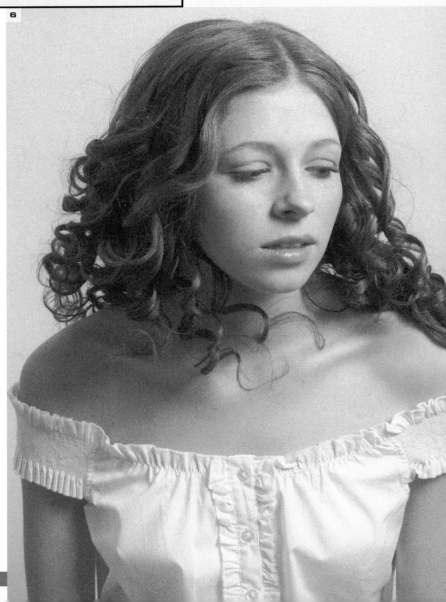

> desaturate

> smudge

> eraser

> film grain filter

> web

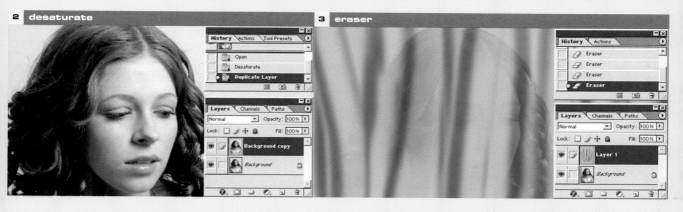

2 desaturate

3 eraser

enhance

A series of manipulations transformed the photo from a regular image to one that looked as if it had been developed in a tank of chemicals and then scraped for effect.

Firstly, the image was desaturated [2] to remove the existing colour, but not converted to greyscale since the colour channels would still be required. A new layer was created and filled with a dingy green colour.

Next, a dark green colour was selected and thick vertical brush strokes applied. The Smudge tool was used to blend the lines in places. Then the Eraser at 25% opacity [3] was used to dab away at various parts to make it thinner.

The blend mode of the top layer was changed to Overlay, and a new layer, filled with a light green colour, was added on top. This used the Multiply mode at 70% opacity. All layers were merged and then the Film Grain filter [4] was applied. This was applied with a Grain setting of 6 to generate lots of grittiness; a Highlight area of 10 to spread it around; and an Intensity of 5.

4 film grain

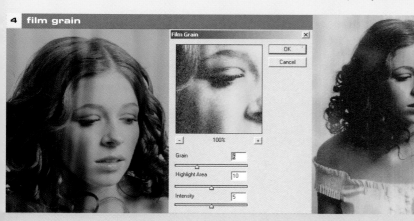

5

enjoy

The Emma in Green variation of this photo [5] was a successful entrant in the Digital Photo Art exhibition (www.digitalphotoart.org). This featured an online submission and resulting gallery of winners and runners-up entries. To be submitted for the competition the original file had to be reduced to 1024 x 768 resolution, which reduced some of the grain effects. These were reapplied to the smaller file before emailing. An admirer of the photo wanted to see what it looked like in sepia and without the scraping effects, so I went back to the original and used the Grain filter to add texture. This generates coloured noise, so was done first. The image was then desaturated and Variations in Photoshop was used to add yellow and red components for a sepia look [6].

1/ The original photo.

2/ The image was desaturated to convert it into mono.

3/ The painted overlay.

4/ A grain effect was added.

5/ The final image.

6/ An alternative version of the image was given a sepia effect.

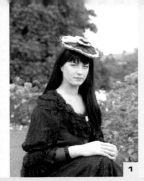

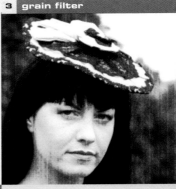

inflicting damage

A pleasing irony of digital imaging is that, while it can be used to restore old photos – repairing cracks, flaking emulsion and boosting faded detail – it can also be used to inflict this very kind of damage on new digital photos. All manner of pictures suit this treatment: the key to getting the right look is to ensure that the worst of the damage is not in vital areas such as the subject's face.

shoot

This shot was taken in a public garden in Whitby, England, using a Fuji digital SLR camera. The model was wearing a Victorian dress, hired from a costume shop. Whitby has strong Victorian connections, including a ruined abbey, and the bones of whales on cliffs overlooking the harbour, and is notable as the place where the coffin carrying Count Dracula came ashore in Bram Stoker's gothic horror novel. This was part of a series of photos taken with the intention of turning them into sepia prints, but this one was singled out for more destructive treatment.

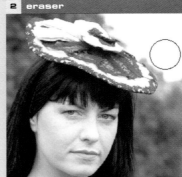

2 eraser

enhance

The first step was to desaturate the image to get rid of the colour and then to crop it to the desired framing. Then the Eraser tool was set at 30% opacity and the edges of the image nibbled away [2]. Once sufficient inroads had been achieved, the opacity was changed to 100% and the corners removed.

Then a duplicate layer was created, and the Grain filter applied using the Vertical Grain option at 32% strength and then again using Regular Grain [3]. The Watercolour filter was applied, and the layer blend mode changed to Multiply. This gave the photo a scraped look with peeling emulsion. However, on its own, this was rather drastic, so the layer opacity was reduced.

The Eraser tool was used to remove the main damage from the face area so that came through clearest of all. The Dodge and Burn tools were used to correct overexposure or to distress the picture more. Variations was used to add the sepia colour. The layers were blended and finally the overall picture made lighter to fade it.

> desaturate

> eraser

> duplicate layer

> grain filter

> watercolour filter

> eraser

> dodge and burn

> variations

> brightness

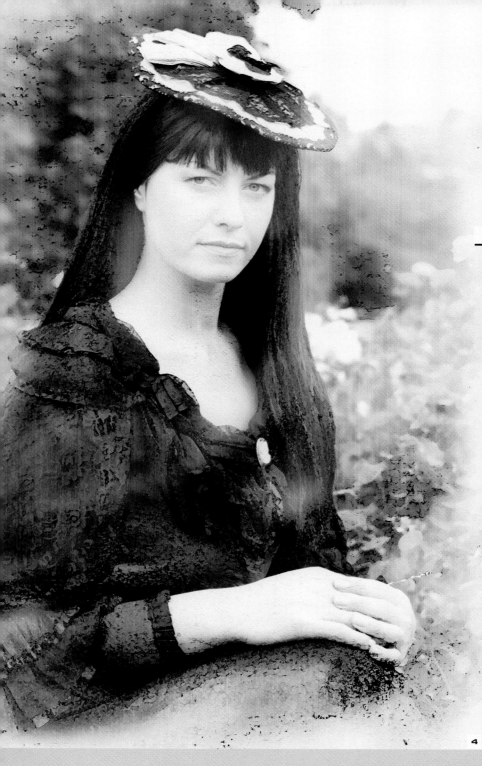

1/ The original image was in colour and featured toneless skies and patches of burn-out.

2/ The Eraser was used to remove areas of the original.

3/ A Grain filter was added to create an ageing effect.

4/ The final image with further creatively destructive effects.

enjoy

The original picture didn't make the grade because of the dismal sky and the slight bleaching of the model's hands and face. That marked it out as a picture with potential for creative vandalism. I liked the end result so much that I decided to print it out at A3. However, the resolution of the picture meant it would be printed at 150dpi. This is the bare minimum to use for ink jet prints, so the image was resampled and resized so that there was a bit more detail to play with. The final picture was printed at 220dpi, on A3 glossy photo paper on a Canon A3 printer.

4

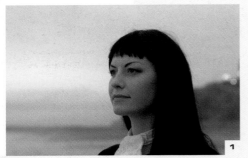

Light was fading on the beach at Whitby, North Yorkshire, as I captured the model looking wistfully out to sea. Over her left shoulder, street lights can be seen twinkling in the distance. As the flash wasn't used, a wide f/2.8 aperture at ISO 160 was required on the Fuji digital SLR camera. The problem with this picture was that the background lacked drama, being slightly overexposed. As this was a moody scene, it was perfect for tritoning.

duotones and tritones

Duotones and tritones give images a sophisticated look combining the power of monochrome with the evocativeness of subtle colour. Duotones consist of two tones. You have white at one end of the spectrum, which merges into the midtone colour as formed by your second duotone colour, which then merges into either black (the default colour) or your first duotone colour. Tritones add a third colour, which is mixed with the second colour to produce the midtone range.

enhance

There was too much spare scenery behind the model to the right, so it needed to be cropped. However, this meant that the twinkling lights would have been lost, so they were cloned first and moved nearer to the model before the image was cropped [2].

A duplicate layer was created and the blending mode set to Multiply.

3 eraser

1/ The original picture was taken at sunset but the background lacked the drama required.

2/ The lights from the original picture were cloned and moved.

3/ The model was removed from the top layer using the Eraser.

4/ A tritone colour was added for an authentic aged look.

5/ The Dodge and Burn tools were used to add further dark areas and highlights.

2 clone tool

This instantly put some drama into the background scenery, but it made the model too dark, so the Eraser was used to remove her from the top layer [3]. In effect, this is just like using a layer mask, but it's quicker. If a mistake is made then pressing Control + Z undoes it.

The colour mode of the picture was changed to greyscale to remove all colour information. The Duotone mode was then selected. From the options box, Tritone was selected and then the two midtone colours were chosen. A brown and a yellow colour were chosen to produce a sepia-like effect [4].

An S-shape Curve function was used to increase the tonal range of the image, and then the Burn tool was used to darken areas of the clouds. The Dodge tool was used to lift highlights on the model's face [5]. Finally, the image was saved in both RGB and CMYK formats.

> clone

> crop

> greyscale mode

> duotone mode

> tritoning

> curves

> dodge and burn

> RGB and CMYK save

4 tritone

Type:	Tritone
Ink 1:	PANTONE DS 325-1 C
Ink 2:	PANTONE DS 2-7 C
Ink 3:	PANTONE DS 68-4 C
Ink 4:	

Overprint Colors...

5 dodge and burn

History / Actions

seaside tritone.tif

Dodge Tool
Dodge Tool
Dodge Tool
Dodge Tool
Burn Tool
Burn Tool
Burn Tool
Burn Tool
Burn Tool

! If you replace the duotone black with something else the result invariably looks muddy with darker colours, so care needs to be exercised.

! A darker second duotone colour will make the photo seem darker but will be more colourful; a lighter duotone will make the image seem lighter but have less effect.

! When using tritones or quadtones (in which three colours are blended together) all the secondary colours are mixed together. As quadtones give much the same colour mix as **RGB**, the real reason for using them is because of the access to specific Pantone colours, usually for a commercial output where the colours must be exact.

The original colour image here was printed quite small in a feature about Victorian Whitby. The RGB tritoned version was printed out at 300dpi at A4 for display on my studio wall, while the CMYK version was submitted for use in this book.

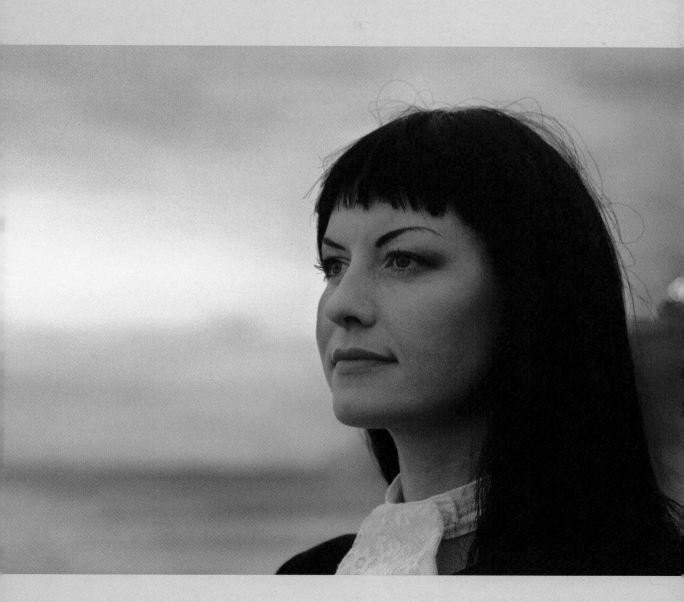

appendix

This image consists of three separate self-portraits of Zosia, taken on a Canon PowerShot using natural lighting next to a window at around noon. The first two photos were taken using a self-timer and the third was taken within arm's reach. The shots were manipulated using the Dodge and Burn tools and the contrast was enhanced by using Levels and the Brightness and Contrast features. A shade of blue was then applied over the top for a subtle addition of colour. The three photos were then compiled into one image.

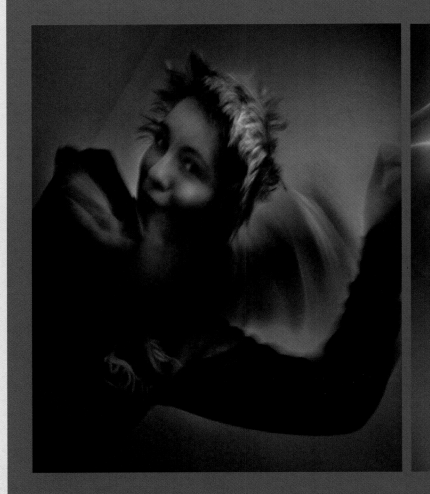

Zosia comments: 'This image is fun – it's a form of surrealism without the unnecessary philosophy. It's a dream-photo in which the author can observe herself.'

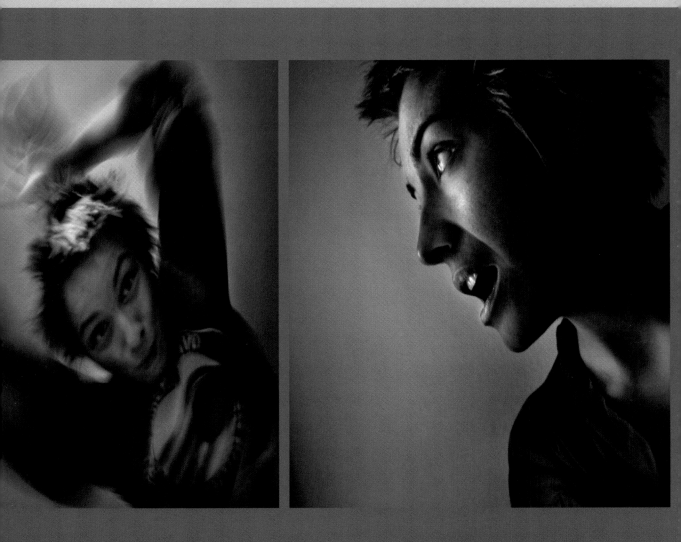

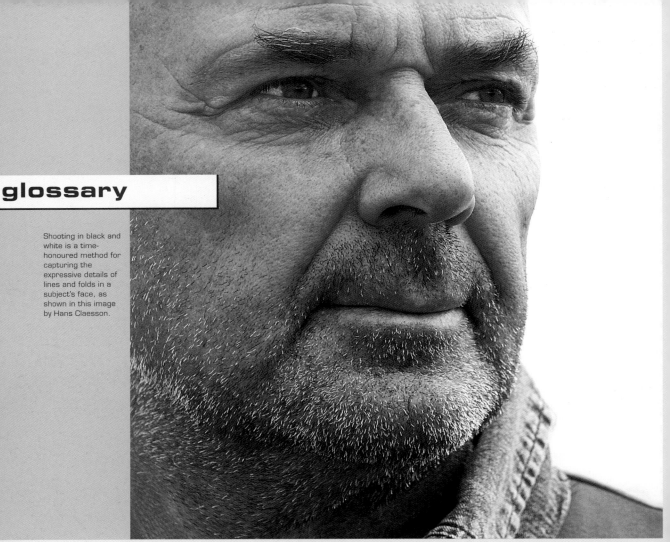

glossary

Shooting in black and white is a time-honoured method for capturing the expressive details of lines and folds in a subject's face, as shown in this image by Hans Claesson.

Aperture: the opening to a camera's lens that allows light into the camera to strike the CCD. See f-stop.

Aperture priority: camera shooting mode. Allows the user to set the camera's aperture (f-stop) while the camera calculates the optimum exposure time.

APS: acronym of Advanced Photo System.

Artefact: minor damage or fault on a photograph, usually caused by JPEG file compression.

Automatic white balance: system within a digital camera that removes colour casts in images caused by the hues of different types of light.

Bit: binary digit. Smallest unit of information used by computers.

Bitmap: digital image made of a grid of colour or greyscale pixels.

Byte: a string of eight bits. 1024 bytes make a kilobyte (KB), and 1024KB make a megabyte (MB).

CCD (charge coupled device): electronic device that captures light waves and converts them into electrical signals.

CD-R: a compact disc that data can be written to but not erased.

CD-RW: CD-RWs can be erased and used a number of times.

Chromatic aberration: colours bordering back lit objects. Caused by the poor quality lens systems used in many compact cameras. Can also affect high-quality optical systems, but only to a limited degree.

CMOS (Complementary Metal Oxide Semiconductor): a light-sensitive chip used in some digital cameras and scanners instead of CCDs. CMOS chips are cheaper to develop and manufacture than CCD chips, but they tend to produce softer images.

CMYK: abbreviation for cyan, magenta, yellow and black – the secondary colours from which colours can be derived. CMYK is used to reproduce colours on the printed page and has a narrower gamut than RGB. See RGB.

CompactFlash: type of memory card with the interface built in.

Compression: process that reduces a file's size. Lossy compression systems reduce the quality of the file. Lossless compression does not damage an image. See JPEG.

Digital image: a picture made up of pixels and recorded as data.

Digital zoom: process that simulates the effect of a zoom by cropping photos and enlarging the remaining image. Reduces image size. See Interpolation and Zoom Lens.

Download: process of transferring data from one source to another, typically a camera to a computer.

DPI (dots per inch): measurement of image size when printed, not its resolution.

Dynamic range: the range of the lightest to the darkest areas in a scene that a CCD can distinguish.

Electronic viewfinder: a small LCD display that replaces optical viewfinders in some digital cameras.

Exposure compensation: adjustment applied to a photograph to correct exposure, without adjusting the aperture or shutter speed.

Exposure value (EV): measurement of a photograph's brightness.

f-stop: a camera's aperture setting. A high f-stop number means the camera is using a narrow aperture.

File size: a file's size is determined by the amount of data it contains.

Film scanner: a device that creates a digital image from slides or developed camera film.

Filter: imaging software function that alters the appearance of an image.

Firewire: Apple's name for the high-speed serial connection IEEE-1394 interface. A Firewire connection allows data transfers of up to 400Mb/s.

Flatbed scanner: device that converts photographs and printed documents into digital data.

Gaussian Blur: the most sophisticated system of blurring parts of or an entire image. Can be used to throw backgrounds out of focus.

Gigabyte (GB): a unit of computer memory, equal to 1024 megabytes.

Greyscale: range of tones between pure black and bright white.

Hotshoe: top-mounted connection to link a camera to an external flash unit.

HTML (HyperText Mark-up Language): programming language used to produce websites.

Icon: graphic symbol representing a file, folder or function.

Image-editing software: program used to manipulate digital images. Also known as image-processing, image-manipulation, photo-editing or imaging software.

Image resolution: number of pixels stored in a digital image.

Ink jet printer: printer that sprays fine dots of ink onto paper to produce prints.

Interpolation: a process to increase an image's resolution by adding new pixels. This can reduce image quality.

JPEG or JPG: file format that reduces a digital image's file size at the expense of image quality.

k/s: Kilobyte per second. A measurement of data transfer rates.

Kilobyte (k or KB): unit of computer memory. Equal to 1024 bytes.

Laser printer: printers that print documents by fusing toner or carbon powder onto paper surface.

LCD (liquid crystal display): small light display. Lit by running a current through an electrically reactive substance held between two electrodes.

LCD monitor: small, colour display built into most digital cameras. Allows the user to preview/review digital photos as they are taken.

Lithium-ion or Li-ion: powerful rechargeable batteries. Not affected by the memory effect (see Ni-Cd).

MAh (milliamp hours): a unit of measure to describe a battery's power capacity.

Mb/s: Megabyte per second. A measurement of data transfer rates.

Megabyte (Mb or MB): unit of computer memory. Equal to 1024 kilobytes.

Megapixel (Mp): a million pixels. A standard term of reference for digital cameras. Multiply the maximum horizontal and vertical resolutions of the camera output and express in terms of millions of pixels. Hence a camera producing a 2400 x 1600 picture would be a 3.8Mp camera.

Memory Stick: Sony's proprietary solid state storage media.

Memory effect: the decrease of a rechargeable battery's power capacity over time.

Microdrive: a miniature hard drive offering large storage capacities that can be used in digital cameras with a CompactFlash Type II slot.

Microsoft Windows: operating system used on the majority of PCs.

MultiMedia Card: type of storage media used in digital devices.

Ni-Cd or Nicad (nickel cadmium): basic type of rechargeable battery. Can last up to 1,000 charges, but can suffer from the memory effect. See Memory effect.

NiMH (nickel metal hydride): rechargeable battery. Contains twice the power of similar Nicad batteries. Also much less affected by the memory effect. See Memory effect.

Optical viewfinder: non-LCD viewfinder found on most cameras.

Outputting: process of printing an image or configuring an image for display on the internet.

PC card: expansion card interface, commonly used in laptop computers. A variety of PC cards offer everything from network interfaces, modems to holders for digital camera memory cards. Some memory card readers use PC card slots. Also known as PCMCIA cards.

PC sync: socket on a camera that allows the camera to control studio flash systems.

Pen tablet: input device that replaces a mouse. Moving a pen over a specially designed tablet controls the cursor.

Photoshop: industry-standard image manipulation program produced by Adobe.

Pixel: tiny square of digital data. The basis of all digital images.

Pixellation: effect when individual pixels can be seen.

Plug-in: software that integrates with a main photo-editing package to offer further functionality.

Printer resolution: density of the ink dots that a printer lays on paper to produce images. Usually expressed as dpi (dots per inch), but note that this is not related to the dpi of an image.

RAW: this file format will record exactly what a camera's CCD/CMOS chip sees. The data will not be altered by the camera's firmware (images are not sharpened, colour saturation is not increased, and noise levels will not be reduced).

RGB: additive system of colour filtration. Uses the combinations of red, green and blue to recreate colours. Standard system in digital images. See also CMYK.

Secure Data (SD): a type of solid-state storage medium used in some digital cameras.

Shutter priority: camera shooting mode. The user sets the camera's shutter speed, while the camera calculates the aperture setting.

SmartMedia: type of storage card used to store digital images. Very popular digital camera format, now replaced by x-D format.

Thumbnail: small version of an image used for identifying, displaying and cataloguing images.

TIFF: image file format. Used to store high-quality images. Can use a lossless compression system to reduce file size, without causing a reduction in the quality of the image. Available on some digital cameras as an alternative to saving images using the JPEG format.

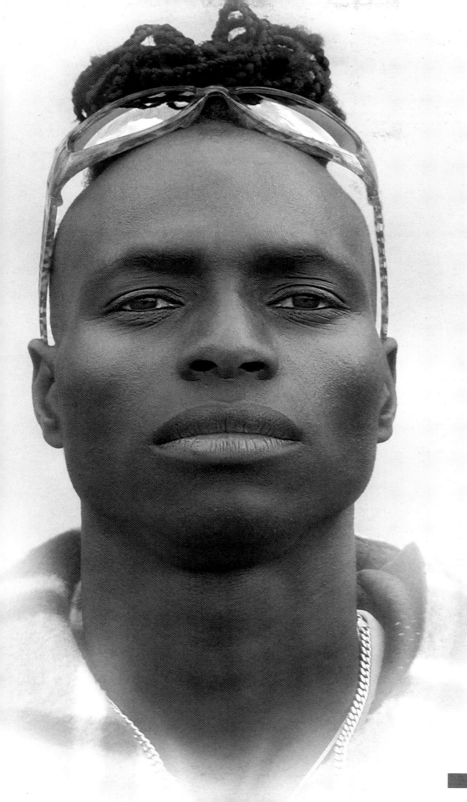

TTL (through-the-lens) metering: a sensor built into a camera's body that uses light coming through the lens to set the exposure.

USB 1.1 (Universal Serial Bus v1.1): external computer to peripheral connection that supports data transfer rates of 1.5Mb/s. One USB 1.1 port can be connected to 127 peripherals.

USB 2.0 (Hi-speed USB): a variant of USB 1.1. Supports data connection rates of up to 60Mb/s. USB 2.0 devices can be used with USB 1.1 sockets (at a much reduced speed), and USB 1.1 devices can be used in USB 2.0 sockets.

WYSIWYG: acronym of 'what you see is what you get'. A term for a computer interface that outputs exactly what is seen on screen.

xD-Picture Card (xD Card): memory card format that has been developed by Toshiba, Fujifilm and Olympus. Designed as a replacement for SmartMedia.

X-sync: the fastest shutter speed at which a camera can synchronise with an electronic flash.

Zoom lens (Optical zoom): a variable focal length lens found on most cameras. Used to enlarge images. Compare with Digital zoom.

Choose a subject with strikingly strong features and your portraits will compose themselves, as with this powerful image by Hans Claesson.

index

Warm, soft colours,
rich skin tones and
contrasting textures
lend pleasing
elements to this
portrait by Zosia Zija.

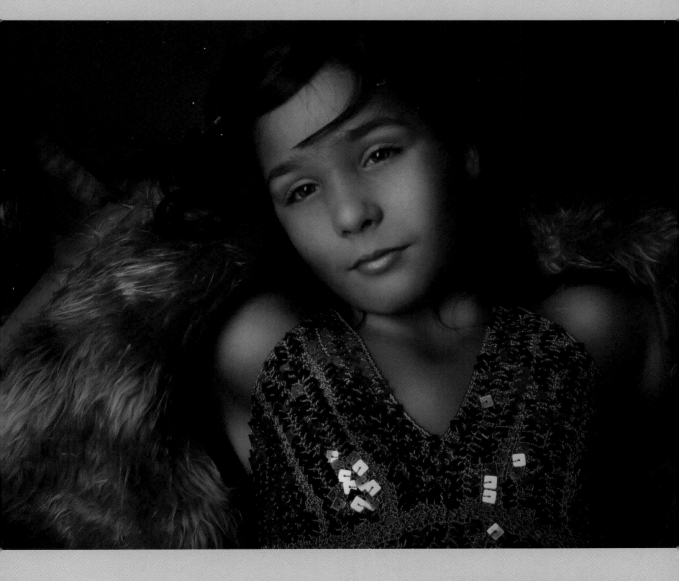

contacts

Theo Berends

Theo Berends describes his work in his own words: 'I photograph on the basis of emotion. The ideas for many of my photographs arise on the spot or during a session. More often than not, a shot entails only the beginning of a process. I linger about what I felt during the shooting, about why, about the backgrounds or the history of the subject. The new information and the new feeling connected with this is added to the photograph at a later moment. For this goal, I make use of modern computer techniques, but I also sometimes scratch the negatives, pile up negatives, or I cut them to create new elements. I keep working on a photograph until my feeling tells me "this is perfect now".'

With specific reference to portrait photography, Theo says, 'When making a portrait, I try to capture more than just the outside. The main thing is that it carries emotion. Only then can a portrait be called successful.'

pages 106–107

www.theo-berends-fotografie.nl

Hans Claesson

Hans Claesson was born in 1966 on a tiny island in the North Sea, just off the western coast of Sweden. Not surprisingly, he has specialised in photographing the changing sea and the shoreline. In addition to his love of the sea, he tries to explore the photographic world as much as possible in many different areas. He thinks of photography not as a documentary medium, but as an art form. He first became seriously interested in photography when the digital revolution started and now uses only digital equipment for his work. He has received numerous awards and honours and has had examples of his work published in magazines and books.

pages 30, 118, 120

www.go.to/photonart

Duncan Evans

The author, Duncan Evans, is a member of Britain's Royal Photographic Society and the Editor of Digital Photography Buyer & User magazine. He has had photographs exhibited all around the UK and published many articles on photographic techniques, digital camera hardware, lighting and Photoshop techniques. His first book, Classic Glamour Photography, covered the techniques of the top photographers as well as offering practical advice. As well as being an expert digital photographer, Duncan has a long track record in consumer journalism, having been the editor of more than ten magazines and contributed to the national broadsheets. Married, with three children, he recently moved from Clacton-on-Sea, Essex, to the Highlands of Scotland to further pursue his twin interests of photography (portraits and landscapes) and writing.

pages 15, 26, 38, 46, 48, 56, 62, 76–77, 80, 86, 88, 90, 92, 96, 98, 100, 104, 108, 110, 112, 114

www.duncanevans.co.uk

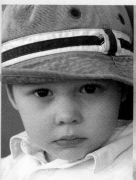
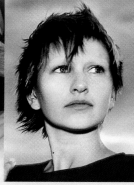
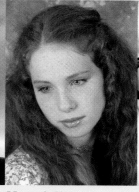
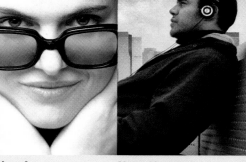

Robert Ganz

Robert Ganz's interest in photography began in the 1970s in Kenya, where he shot with an old Exakta 35mm and had his own darkroom. He rediscovered photography with his first digital camera in 2000 and has been passionate about it ever since. He is strictly an amateur, but spends almost all his free time and spare money on his hobby. He shoots Canon, and currently uses a 10D with a variety of lenses.

page 20

www.digitalphotocontest.
com/archivedisplay.asp?pho
tographerid=6550

Gry Garness

Norwegian-born photographer Gry Garness has been based in London's East End since 1993. She considers herself to be mostly self-taught in the technical aspects of photography, but now also teaches both photography and Adobe Photoshop. She has worked within fashion, editorial, advertising and music photography since 1996 and has specialised in digital imaging since 2000. Having started out in photography before the digital revolution, Gry still aims to get a perfect shot using analogue methods; good exposure on film, good lighting and composition, etc. She uses black-and-white analogue fine printing and toning where appropriate, but most of her images are scanned digitally and enhanced to some degree in Adobe Photoshop. She usually does digital retouching on her commissioned work, as it allows her to follow through the idea and achieve the pre-visualised shot. She mainly shoots on Fuji GX 680 III, Sinar and Nikon.

cover; pages 52–53

info@grygarness.com
www.grygarness.com
www.ggarness.dircon.co.uk

Marc Jaffe

Marc Jaffe strives to blur the line between commercial photography and fine art by combining his passion for the amazing quality of light with his unconventional approach to imagery. His work has been published in several professional photography books and exhibited at art shows and galleries in New York, Connecticut and Virginia. Photographer, graphic artist and website designer, Marc studied at Art Center College of Design in Pasadena, CA and Museum School of Fine Arts in Boston, MA.

pages 34–35

www.marcjaffe.com

Helen Jones

Based in Greenwich, UK, photographer Helen Jones was born in 1965. Specialising in portraiture, Helen has produced a number of art installations. She has supplied Conran's Soho restaurant, Mezzo, with more than 500 images over the past few years and her work has been published in various magazines and books. Exhibitions of her work have been held at Mezzo, Joe's Basement and Rhythm Design.

pages 17, 36, 42, 50, 64, 72, 84–85, 94

www.platosgirlfriend.co.uk
www.helenjones
photography.co.uk

Yann Keesing

Photographer and painter Yann Keesing specialises in portraits, cityscapes and black-and-white images, particularly of New York City. Further examples of his work can be found on the website listed below.

pages 60–61

www.pbase.com/ykeesing

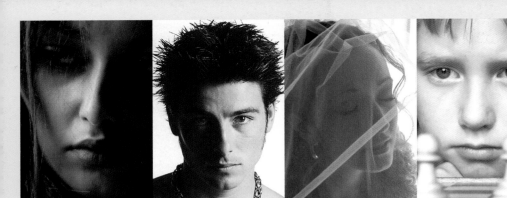

Konrad

Jacek Jedrzejczak (known as Konrad) lives in Warsaw, Poland. He first got a camera when he was eight years old. He took photographs for his family until 1996, when he started a new artistic career. He now specialises in portraits, nudes, landscapes and abstract work. Among his awards for photography are a bronze medal for Poland's Photographic Championships of 2002 and a silver medal in Argentina's Salón Internacional de Imagen Virtual of 2002.

page 78

grzesio47@poczta.onet.pl
www.photostudio.w.pl

Caesar Lima

Caesar Lima specialises in professional fashion, beauty and product photography. The merging of photography and computers is what gives his work an edge. Caesar continually checks out new innovations such as computer-controlled robot lights. 'I am an open door to new ideas, open 24 hours a day,' he says. When thinking about the future, Caesar sees technological advances that will make it possible to exceed current limits and maximise artistic creativity.

page 33

www.caesarphoto.com

Andrew Maidanik

Andrew Maidanik was born in Odessa, Ukraine, in 1975. He became fascinated with photography at the age of eight, when his grandfather gave him his trophy 1945 Carl Zeiss 6x9 camera. Shooting portraits and landscapes and spending long hours in a darkroom developing film and making prints has been his lifelong fascination, which transformed into a professional career after his emigration to Canada. Since then Andrew has experimented with a variety of different cameras and techniques. Since 1999 he has developed extensive expertise in digital photography, which continues to captivate him with its virtually endless possibilities.

pages 70, 74, 82

www.andrewmaidanik.com

Heather McFarland

Michigan, USA-based Heather McFarland retired from a 20-plus year career as a systems engineer in 2000 in order to pursue a second career as a photographer. She had been casually shooting 35mm since 1987, but didn't seriously get into photography until she got her first digital camera in 1998. She found the instant feedback and ability to control all aspects of image editing very appealing. Heather likes to photograph a wide variety of subjects and feels that almost anything can make a good image if presented in an interesting way. She is drawn most to the graphical elements found all around us. She strives to incorporate and highlight those elements with images containing strong lines and bold colours.

pages 22–23

www.hkmphotos.com

Gordon McGowan

Gordon McGowan is Scotland's highest qualified wedding photographer, gaining his Fellowship in wedding photography from the British Institute of Professional Photography and also the Master Photographers Association in 2002. Gordon has been a professional photographer since 1991 and specialises in wedding and portrait photography. Gordon's distinctive style of wedding images, which has won him numerous awards, is stylish, creative and contemporary. His images reflect the individuality and personality of each bride and groom and are taken with his passion for creating a fresh and innovative way of photographing weddings.

pages 68–69

www.gordonmcgowan.co.uk

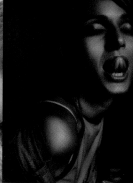

Paul Rains

American photographer Paul Rains says, 'photography has been a joy of mine since childhood. Developing black-and-white negatives in a poorly ventilated basement and burning light-sensitive sheets of photo paper with the enlarger…well, we've come a long way. Now digital has opened much greater (and cleaner!) avenues of creativity. Whether I'm at home in the Missouri Ozarks or on one of my semi-annual mission trips, I enjoy taking photographs of nature, people and a variety of other subjects.'

pages 66–67

www.paul.smugmug.com

Shelley Sanders

Shelley Sanders is a published award-winning photographer. After retiring from her real estate career, Shelley taught herself photography and Photoshop, winning numerous contests along the way. Her favourite subjects are people and portraiture, still life/concept, and food and drink. From colour to black and white, high key to intense shadows, Shelley enjoys working with light to produce eye-pleasing photos with either graphic or aesthetic presence. She creates images to evoke emotion from the viewer; she wants the viewer to be pulled in by her images and for those images to stay in the viewers' thoughts. Shelley is now pursuing a professional career in advertising.

pages 18, 19, 24, 102

www.shelleysandersphoto graphyandstock.com

Trine Sirnes

Norwegian photographer Trine Sirnes is something of a newcomer to photography, but in 1999 she borrowed a digital camera from a friend, a Leica Digilux Zoom, and a whole new world opened to her. She says: 'instead of taking out a film and waiting for it to be developed, forgetting about all the things I did when I took the photo, I could now plug it in to my computer and see right away if it was a keeper or not.' For Christmas 1999, Trine got her own digital camera, a Nikon Coolpix 880, which she still uses. Trine uses the internet a lot; it has given her friends all over the world who share her passion for photography. She is a member of several communities and forums dedicated to photography. She participates in contests on the net, and has won quite a few of them.

pages 4, 10–11, 54, 58

www.SirnesPhotography. com

Darwin Wiggett

Darwin Wiggett works as part of Natural Moments Photography along with his wife, Anita Dammer. Darwin has been shooting stock since 1990, and has published two books (Darwin Wiggett Photographs Canada and Seasons in the Rockies). Together, Darwin and Anita specialise in landscape, nature, animal, humour and children and are the Editors-in-Chief of Canada's Photo Life magazine.

page 28

www.portfolios.com/ NaturalMoments Photography
www.photolife.com
www.Darwin.imageculture. com

Zosia Zija

Zosia Zija lives and works in Poland and has always been fascinated by film-making and cinematography. She started her career as a photographer in 2002 and in February 2003 her work was exhibited in Warsaw, Poland, where her showcase 'In and Out of Ourselves' was a great success. Her interest in portrait photography is reflected in her images of people in their surroundings; she documents the relationship between people and places they live. Zosia has had further exhibitions in Poland and in Milan, Italy.

pages 7, 40, 44, 116–117, 123

zosia@zija.net
www.zija.net

acknowledgements

I would like to thank the following people for their invaluable assistance in the production of this book. Firstly, Nicola Hodgson for unlimited patience, good ideas, lots of help and recommending me for the job in the first place – many thanks. Sarah Jameson for great picture research and digging out a wide variety of contributors from all over the world. Bruce Aiken for his excellent designs. Brian Morris and the editorial team at AVA Publishing SA. My daughter Chloë for coming up with a picture when we were stuck for a family portrait, and my wife Kerry for the support and encouragement throughout the project. Finally, to all the photographers who contributed their excellent portrait photographs, particularly Helen Jones for all her great photos and boundless enthusiasm.

Cover image
Tattooed Lady by Gry Garness

Copyright
Gry Garness
(www.grygarness.com)

Bodypaint
Emma Jane Cammack
(www.emmacammack.com)

Make-up and hair
Carol Morley

Styling
Sam Magee

Model
Estella @ Premier Models,
London